IMAGES
of America

Arnold Arboretum

ON THE COVER: Ladies are in the lilac (*Syringa*) collection in full bloom on a cool day in late May 1926 in this photograph by Walter R. Merryman. (Courtesy of the Archives of the Arnold Arboretum.)

IMAGES
of America

ARNOLD
ARBORETUM

Lisa E. Pearson

Copyright © 2016 by Lisa E. Pearson
ISBN 978-1-4671-3485-9

Published by Arcadia Publishing
Charleston, South Carolina

Printed in the United States of America

Library of Congress Control Number: 2015943162

For all general information, please contact Arcadia Publishing:
Telephone 843-853-2070
Fax 843-853-0044
E-mail sales@arcadiapublishing.com
For customer service and orders:
Toll-Free 1-888-313-2665

Visit us on the Internet at www.arcadiapublishing.com

Contents

Acknowledgments		6
Introduction		7
1.	Before the Arnold Arboretum	11
2.	Forming the Arnold Arboretum	23
3.	Around the Arnold Arboretum	37
4.	Arnold Arboretum Activities	87
Bibliography		126
Index		127

ACKNOWLEDGMENTS

I would like to thank Dr. William "Ned" Friedman, director of the Arnold Arboretum, for his support and encouragement during the preparation of this book. I would also like to thank my colleagues in the arboretum library, Larissa Glasser and Stephanie Turnbull, for their invaluable assistance with scanning, retrieving documents, and proofreading as well as keeping the library running while I was busy writing. In addition, I would like to thank the arboretum's director of external relations and communications, Jon Hetman, for his keen editorial eye. Unless otherwise noted, all images are drawn from the Archives of the Arnold Arboretum.

Introduction

For nearly 150 years, the Arnold Arboretum has been a shining jewel in Boston's Emerald Necklace chain of city parks. It is a restorative refuge for city residents where they can enjoy nature's beauty and serves as an educational institution providing learning opportunities for all ages. In addition, it is the site of cutting-edge scientific research on woody plants, climate change, and urban ecosystems.

In prehistory, the arboretum landscape played host to native peoples who hunted and fished in the wetlands. Europeans settled here soon after the town of Roxbury was founded, harvested timber from the abundant forests, and planted fields with crops. The Weld family and other early residents in the Jamaica end of Roxbury built a thriving community and raised a meetinghouse on Walter Street, the burying ground of which still remains today. At the beginning of the 19th century, goldsmith, merchant, and mill owner Benjamin Bussey (1757–1842) purchased an estate, which gradually expanded over the next 40 years. These lands, which he bequeathed to Harvard University, would become the Arnold Arboretum. However, land alone cannot make a viable institution—financing is also required—and this came from New Bedford merchant James Arnold (1781–1868). It was Arnold's generous monetary bequest coupled with Bussey's land that created the Arnold Arboretum in 1872. The new arboretum soon gained a young energetic director in the person of Charles Sprague Sargent (1841–1927). The 32-year-old Civil War veteran immediately set to work and soon enlisted the help of Frederick Law Olmsted (1822–1903), the planner of New York's Central Park, to design the road system and develop planting plans for the grounds. It soon became apparent to Sargent that to accomplish his goals for the institution, he would have to find a way to cover the costs of the infrastructure—roads, walls, and sewers. In 1882, he worked out a plan whereby Harvard University would give the arboretum land to the City of Boston and then lease it back for $1 a year for 1,000 years. In return, Boston would build and maintain the infrastructure and provide security, freeing Sargent to devote his budget to developing the arboretum. During the 1880s and into the early 1890s, the landscape began to take shape, and the roads were built. In 1886, the first major planting initiative took place, emptying propagator Jackson Thornton Dawson's (1841–1916) nurseries, which had been filled to overflowing.

During this time of intensive building of the landscape, Charles Sargent was also engaged by the US government in 1880 to conduct a census of American forests as part of the 10th census of the United States. He was also busy writing his *Silva of North America*, which described our native tree flora. The 14-volume text was brilliantly illustrated by arboretum herbarium and library director Charles Edward Faxon (1846–1918). Sargent's passion for forestry carried forward when he began publication of the weekly periodical *Garden and Forest* in 1888. This seminal publication created a forum for some of the leading thinkers of the day on the subjects of conservation, urban parks, forestry, garden design and criticism, and botany. In addition, the journal was an unofficial voice of the Arnold Arboretum and included many articles by arboretum dendrologist, educator, and plant collector John George Jack (1861–1949), who was the face of visitor education for the institution for decades. Jack also provided instruction in dendrology for a generation of Chinese students pursuing advanced degrees through the Bussey Institution of Harvard University, who found it easier to study the flora of their country all conveniently displayed in one place.

Charles Sargent was also a world traveler, and in 1892, he journeyed to Japan. This trip settled his mind on the need for the arboretum to collect plants in the temperate parts of Asia. The relationships between plants from eastern North America and Eastern Asia (disjunct floras) had been most forcefully articulated by Harvard University professor of botany Asa Gray in the middle of the 19th century. This work helped ignite Sargent's interests in Asia, and the trip allowed him to make permanent contacts with Japanese botanists who would work closely with arboretum colleagues over the years. In 1905, John Jack spent six months in Asia, visiting Japan, Korea, and China. As part of his itinerary, he journeyed to Hokkaido, Japan, and called upon Harvard-educated Prof. Kingo Miyabe (1860–1951) of the Sapporo Agricultural College, whom Sargent had visited in 1892.

In 1906, Sargent engaged a young Englishman, Ernest Henry Wilson (1876–1930), to explore China for the arboretum. Wilson, who had already made two trips to China for the Veitch nursery firm, was tasked with collecting woody plants in Hubei and Sichuan Provinces for three years beginning in early 1907. His expedition was extremely successful, and he returned with thousands of seeds, specimens, plant material, and spectacular photographs. The next year he went again, but this trip was cut short when he was caught in a landslide in western Sichuan. Rocks crushed his leg, and he was forced to return to the United States early.

While Wilson was in Sichuan, another young Englishman named William Purdom (1880–1921) was exploring for the arboretum in Shaanxi and Gansu Provinces. He did not collect as much plant material as his colleague, but his photography was particularly successful. Purdom favored wide vistas of the mountains and valleys of China such as those from Jehol (Chengde, Hebei Province). He also proved a gifted portraitist, capturing for posterity a rich anthropological and ethnographic record of the people from the Tibetan border region.

After recuperating, Ernest Wilson explored Japan in 1914. On this trip, he focused his study on native forests, cultivated plants, and horticultural practices, using the well-developed railroad system in the country to assist his exploration. He directed special attention to Japanese flowering cherries and learning more about Kurume azaleas, which he saw in a nursery in the Angyo district of Kawaguchi. He returned from 1917 to 1919 and also collected in Korea and Taiwan. From a scientific point of view, this is considered Wilson's most important expedition. During this trip, he successfully collected a selection of azaleas in the small town of Kurume on Kyushu.

An arboretum collector again explored China in the person of Joseph Rock (1884–1962), who collected 20,000 herbarium specimens and many packages of propagative material in Yunnan, Gansu, and Tibet from 1924 to 1927. Although few new species were found, he achieved Sargent's principal objective, which was to collect hardier forms of species that had already been collected by others. Rock took numerous photographs and studied the cultures and languages of the local peoples, including the Naxi.

Women have been associated with the Arnold Arboretum since the days of Charles Sargent and served in many capacities, from administrative roles to research and plant exploration. Although this was a time when the professional world was male-dominated, Sargent was encouraging to women who were making their way in the field of landscape design, such as Beatrix Jones Farrand (1872–1959). A number of female staff members were quite long-serving, like librarian Ethelyn Tucker (1871–1959), who began under the direction of Charles Faxon and after his death assumed management of the library until her retirement in 1940, and Susan Delano McKelvey (1883–1964), who started in 1919 by washing pots in the greenhouse, wrote three major books, botanized in the American Southwest, and served on the arboretum visiting committee until her death in 1964. One of the most remarkable was Dr. Shiu Ying Hu (1908–2012), who received her doctorate from Radcliffe and came to the arboretum in 1950 as a specialist in the Chinese flora. During that country's closure to the West, she provided a conduit for colleagues to receive Western botanical literature and stay abreast of scientific developments. Although she officially retired in the 1980s, she continued her botanical work until the end of her long life.

The Great Depression meant hard times for America, and it was no less true for the Arnold Arboretum. In spite of the successful Sargent Memorial Fund campaign initiated by Oakes

Ames (1874–1950) in 1927, budgets were tight throughout the 1930s, and maintenance was sometimes deferred. Extremely cold winters early in that decade killed many less-hardy plants, and the devastating 1938 hurricane wreaked havoc on the landscape. In a spirit of doing more with less, powered horticultural equipment began to be used more and more by the grounds staff. This need became even more pressing with the outbreak of World War II, when a number of employees were drafted into military service. After the war, there was much work to be done to groom the grounds, but work went forward under the watchful eye of arboretum horticulturist Donald Wyman (1903–1993). Wyman also took up John Jack's mantle of public education and led numerous popular field classes on the grounds. He was also the author of a series of successful gardening titles, including the *Arnold Arboretum Garden Book*, *Shrubs and Vines for American Gardens*, and *Wyman's Gardening Encyclopedia*. After more than a half a century of being placed in remote locations, the arboretum propagation facilities finally received a permanent home in 1962 when the Charles Stratton Dana Greenhouses were constructed just a stone's throw from the white-frame farmhouse where Jackson Dawson raised plants for the arboretum for decades.

In 1972, the arboretum observed its 100th birthday with a year of celebrations and special programming. The centennial observations raised public awareness of the arboretum and brought increased visitation, but unfortunately resources could not keep pace. Reflecting the situation in Boston as a whole, the arboretum suffered in that period from vandalism and crime. The implementation of the Boston Park Rangers program in the 1980s and increased support eventually helped reverse this trend. There was an awakening of interest in this period of Frederick Law Olmsted's landscape designs, which led to a reexamination of his original plans for the arboretum. A restoration plan was implemented to return to aspects of Sargent and Olmsted's original vision. This included the creation of the Eleanor Cabot Bradley Collection of Rosaceous Plants in the area adjacent to Meadow and Forest Hills Roads and a resiting of members of the rose family there. Major restorations of several of footpaths, including Oak and Willow Paths, were undertaken to repair the damage they had sustained due to decades of erosion.

After a period in the mid-20th century in which the arboretum did not actively collect plants in temperate Eastern Asia, arboretum botanists returned to the region in the fall of 1977 when taxonomists Stephen Spongberg and Richard Weaver collected in Northern Japan and the Republic of Korea. The 1980s saw the arboretum finally return to plant collecting in China after the country shut its doors to the West in 1949 in the wake of the Communist revolution. In 1980, arboretum botanists collected in western Hubei Province at Lichaun Xian and the Shennongjia Forest District with Chinese colleagues as part of the Sino-American Botanical Expedition (SABE). This expedition was the first of a series of collecting expeditions that continue to the present day in association with organizations such as the North America-China Plant Exploration Consortium (NACPEC). The SABE collaboration led to an English-language version of the *Flora Republicae Popularis Sinicae* and has resulted in the publication of the monumental 25-volume *Flora of China*.

The past decade has seen a rededication by the arboretum to scientific inquiry with the opening of the Weld Hill Research Building, its first major construction in 50 years. This state-of-the-art facility houses 12 greenhouses, laboratories, growth chambers, study areas, and offices and supports three faculty research laboratories, including that of arboretum director Dr. William "Ned" Friedman. Likewise, the revitalization of the Boston neighborhoods that border the Arnold Arboretum has brought an ever-increasing pride and appreciation from visitors for this beloved oasis of green in the midst of their city. As we near the 150th anniversary of the founding of the institution in 2022, we can take pride in the accomplishments of the past and look forward to progress in science, horticulture, and education in the future.

One

BEFORE THE ARNOLD ARBORETUM

The landscape of the Arnold Arboretum was formed by the advance and retreat of glaciers during a succession of ice ages that covered the region. The hills that feature so prominently in the landscape are called drumlins and are in reality enormous piles of gravel, sand, and stone deposited by those glaciers. The solid rock found in outcrops on the grounds is a specific type of conglomerate called Squantum Tillite, which is related to Roxbury Conglomerate, the common rock of the area. Native peoples' occupation of the lands that would become the Arnold Arboretum extend as far back as the Middle Archaic Period, 8,000 to 5,000 years before present (YBP). However, the bulk of archaeological finds, such as projectile points, date to the Late Archaic Period (5,000–3,000 YBP). Native peoples' activities on the arboretum landscape included fishing in the streams and brooks and waterfowl hunting in the marshy areas. The Woodland Periods (3,000–400 YBP) saw native populations moving from the uplands of Jamaica Plain to the coast and riverine areas starting about 2,000 years ago. European explorers and fishermen first made contact with the native peoples of this region over 400 years ago. Roxbury was settled by Europeans in 1630, and the area called Jamaica Plain soon followed. Settlers planted farms, and parcels of property were bought and sold. A Congregational meetinghouse was built in 1711 on Walter Street and a burying ground established soon after. By the early 19th century, Benjamin Bussey had acquired a large estate, and by his death in 1842, he owned most of the property that would later become the Arnold Arboretum.

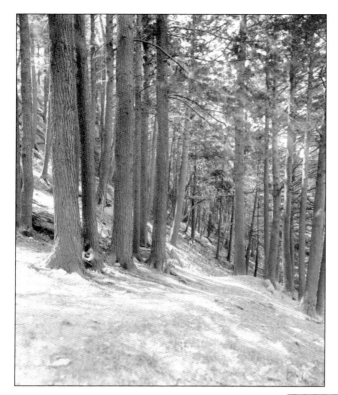

A path on Hemlock Hill is featured in this May 1903 photograph by Thomas E. Marr. Although this hemlock (*Tsuga canadensis*) forest is not the same tree cover from the ancient period, it reflects the forestation of the arboretum nearly 6,000 years ago during the Middle Archaic Period, which was largely composed of hemlock and oak.

Discoveries of stone implements show that native peoples inhabited arboretum lands from the Middle Archaic period. This Neville Variant projectile point from that period was chipped from grey felsite rock with a stem at the base. It would have been mounted onto a slender projectile shaft and propelled by a spear thrower. Arboretum collector-botanist Ernest Jesse Palmer (1875–1962) found it and many others from the arboretum's ancient past on the grounds in the 1920s.

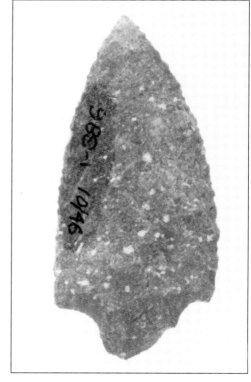

Ernest Palmer had a nearly 50-year association with the arboretum. He was born in England but moved to the United States when he was three years old, finally settling in Webb City, Missouri. In 1900, he became a protégé of botanist Benjamin Franklin Bush (1858–1937), who was collecting hawthorns (*Crateagus*) for the arboretum. Palmer accompanied Bush on his trips in Missouri and surrounding states as a pupil, guide, and eager assistant. He was a collector at large for the arboretum for the next 20 years. Charles Sargent offered him the job of collector-botanist on staff in 1921, a position which he held until his retirement in 1947. Palmer began to collect native peoples' artifacts on the arboretum grounds in 1921. A portion of the collection was put on display in the lobby of the Hunnewell Building in 1945. On his retirement, Palmer entrusted the care of the collection to Alfred Fordham (1911–2000). Fordham continued to add to it in the ensuing years, and upon his retirement in 1977, the Arnold Arboretum Library became steward of this significant collection.

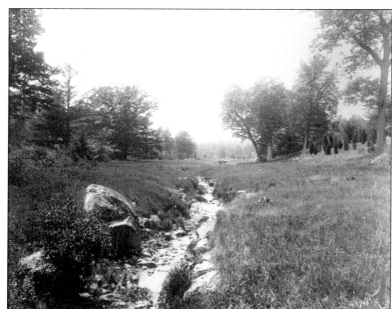

Thomas E. Marr captured this view of the Bussey Brook valley looking west in May 1903. This portion of the arboretum grounds was frequented in the Middle Archaic period by native peoples who fished in the brook and perhaps hunted waterfowl in the marshy areas of the landscape.

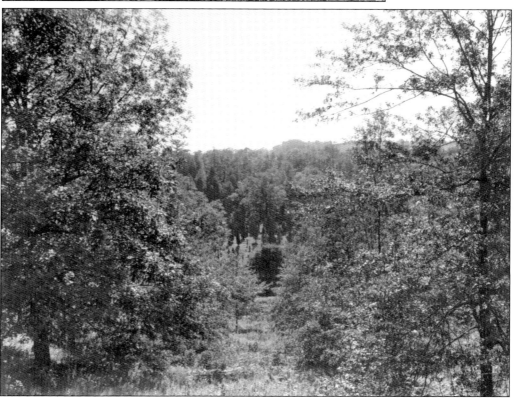

This view from Bussey Hill through the oak collection to Hemlock Hill and Spring Brook was photographed by George R. King in October 1917. Due to climatic warming, the Late Archaic period (about 4,000 years ago) saw a transition of forestation to oak and hickory trees from the hemlock forest that had covered the land previously.

This white-quartz projectile point is known as a Squibnocket Triangle and dates to the Late Archaic period. When making tools, native peoples looked for stone that would produce a sharp cutting edge. Flint and chert are easily worked but not found here. Quartz and felsite are common in this area, but when those could not be found they used materials such as slate, quartzite, or trap rock.

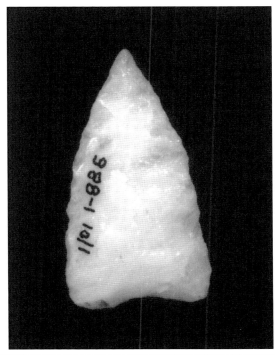

Noted plant explorer Joseph Rock captured this view in the oak collection in September 1945. The open, parklike landscape seen here would be familiar to native peoples of the Woodland Periods. They were careful stewards of the land and managed undergrowth by controlled burning, which limited thicket growth and created a habitat favored by deer.

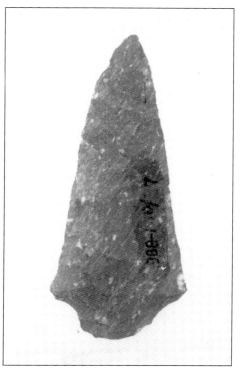

This Fox Creek projectile point of pink-banded felsite dates to the Middle Woodland period. The Woodland Periods (3,000–400 years ago) are characterized by advances in native technology with the introduction of ceramics and agriculture. Native populations moved to the coast starting about 2,000 years ago, and for the most part, habitation within the boundaries of the arboretum disappeared, with the landscape only visited by occasional hunting parties.

Albert Bussewitz (1912–1995) captured this view of the Bussey Brook valley around 1975. Pictured here is the slope of the landscape as the brook flows toward the South Street Gate. This portion of Bussey Brook was dammed in the early 17th century by European settlers and used to power a sawmill.

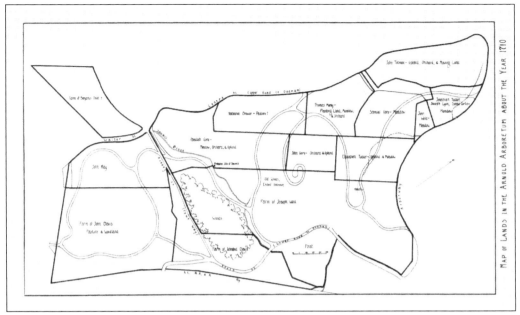

This is a map of the arboretum grounds with the road system and points of interest overlaying a map of the Colonial property boundaries from about 1710, as determined in the research of Hugh Raup (1901–1995) in the 1930s. At that time, most of the holdings were fairly small, with pastures and orchards predominating.

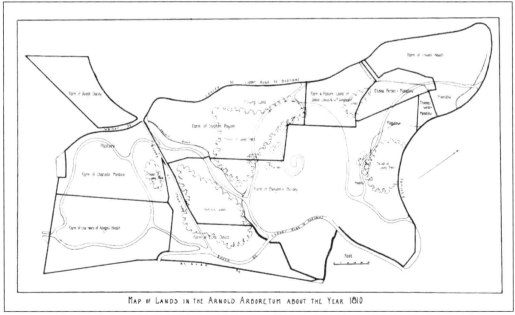

This map shows the property holdings of the land that would become the Arnold Arboretum around 1810. Note that the small holdings have been combined into larger farms, with the biggest landowner being Benjamin Bussey. He would continue to add to his property through his life and by his death in 1842 would own the majority of the land.

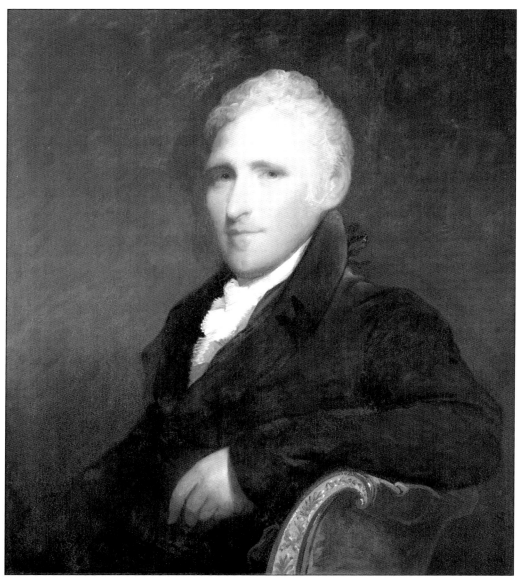

Benjamin Bussey was born to a farming family in Stoughton, Massachusetts. He fought in the American Revolution and served as a quartermaster. After the war, he apprenticed to a goldsmith but soon branched out into trade with Europe. Later, he invested in wool mills in Dedham, Massachusetts. His growing wealth allowed him to buy and sell real estate, and he became one of the largest landholders in Bangor, Maine. Closer to home, he acquired a large estate in Jamaica Plain on which he practiced experimental agriculture, as did a number of prominent men of his era. He was an active member of the Massachusetts Society for Promoting Agriculture, the Massachusetts Horticultural Society, and an early proprietor of Mount Auburn Cemetery (although he was buried in the churchyard of the First Church, Unitarian, in Jamaica Plain). On his death, he bequeathed his land to Harvard College to promote education in agriculture, but it was over 20 years before the college would act on his generous gift. Here, Bussey is seen in a portrait by Gilbert Stuart from 1809. (Courtesy of Harvard Art Museums/Fogg Museum, Harvard University Portrait Collection, Bequest of Benjamin Bussey, 1894, H91.)

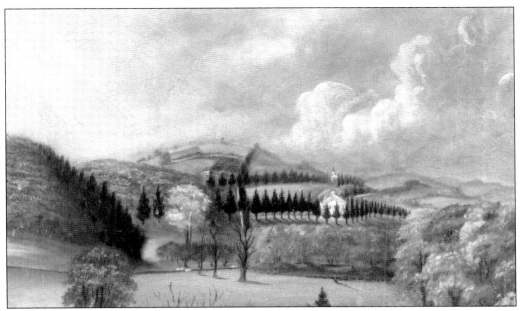

The oldest original image of Bussey's property is this painting by William A. Cobb, dating to 1839, titled *Seat of Benjm. Bussey, Esqr Roxbury (from Walk Hill)*. Viewed from the area occupied today by Forest Hills MBTA Station, this painting shows his white Federal-style mansion, Woodland Hill, and his lands beyond. Of note is his observatory on the hill behind the house, where he kept two telescopes for astronomical viewing.

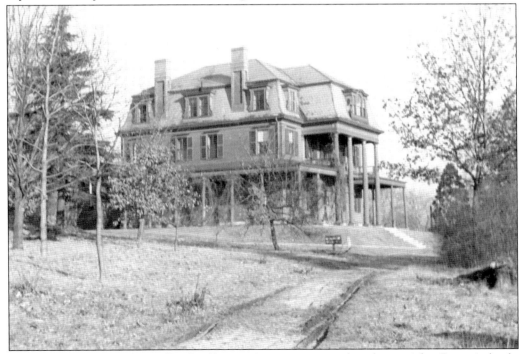

This is a photograph of Woodland Hill in 1940 just prior to its demolition. After Bussey's death, the house was occupied by his descendants, who had been granted life tenancies in his will.

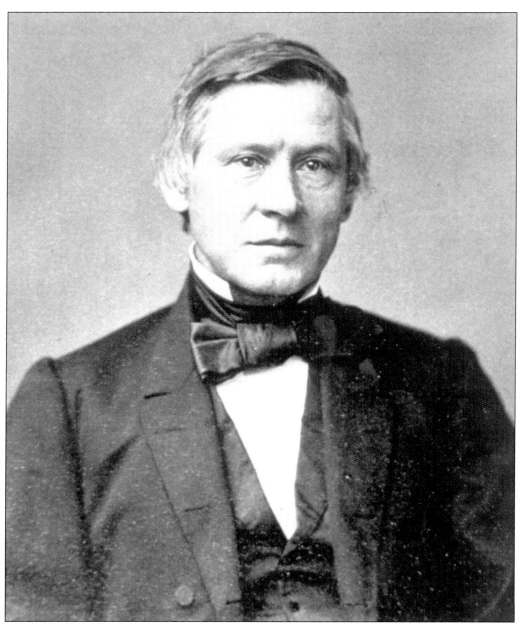

Asa Gray (1810–1888) was born in New York state. He trained as a physician but only practiced for a year, instead becoming a protégée of botanist John Torrey. His work with Torrey and other activities in the natural sciences community led to his appointment as the Fisher Professor at Harvard University. There he taught and managed the Harvard Botanic Garden in Cambridge. He was an early supporter in America of Charles Darwin and the theory of evolution. They shared a decades-long correspondence, and it was Gray who first reviewed On the Origin of Species in an American journal. Gray was the first botanist to recognize the similarities between the flora of eastern North America and that of Eastern Asia, a concept know today as disjunct floras. It would become hugely important for the arboretum in the early 20th century, when plant explorers were dispatched to collect exotic specimens for inclusion in the living collections.

Long before Benjamin Bussey's bequest of his estate and the creation of the Arnold Arboretum, he had welcomed the public to visit his property and enjoy the beauty of the landscape. The opening of a train station in 1835—in the area where Forest Hills MBTA Station is today—made it easy for visitors to reach Jamaica Plain. Harriet Manning Whitcomb wrote in 1897, "During Mr. Bussey's life, and for years after, the public enjoyed the freedom of these charming grounds. There were lovely wood paths, carefully kept, in all directions. Here was a rustic bridge spanning the jocund brook; there a willow-bordered pond, the home of gold and silver fish. This path wound back and forth to the summit of Hemlock Mountain, where (there) was an arbor with seats for resting, surrounded by majestic trees, and where lovely vistas of the distant hills and nearer valley could be enjoyed." This photograph by Thomas E. Marr from May 1903 is perhaps a bit evocative of Whitcomb's prose.

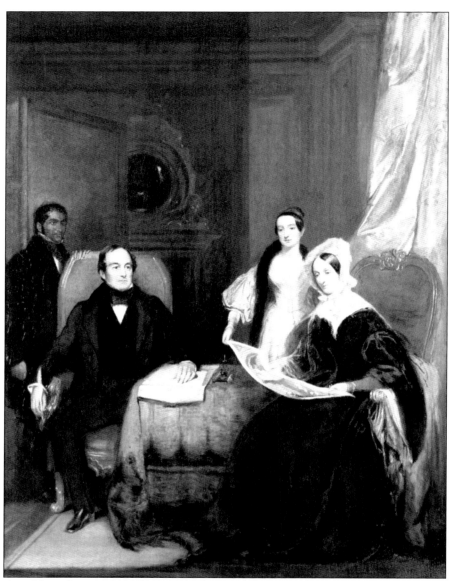

James Arnold was born in Providence, Rhode Island, but moved to New Bedford, Massachusetts, as a young man to pursue a career in the whaling industry. He soon became a partner in the Rotch firm and began to amass a fortune from the lucrative trade. His wealth allowed him to dabble in horticulture and create a large estate, which he landscaped with design elements popularized by John Claudius Loudon and Andrew Jackson Downing. He was a longtime member of the Massachusetts Horticultural Society. Arnold made a generous monetary bequest with the intention that it be used to create an arboretum. Through the efforts of George Barrell Emerson (1797–1881), Arnold's brother-in-law, and an executor of his estate, Arnold's bequest was transferred to Harvard College where it was joined with Bussey's land to create the Arnold Arboretum on March 29, 1872. Pictured in this 1837 portrait are, from left to right, an unidentified man, James Arnold, Elizabeth Arnold (daughter), and Sarah Rotch Arnold (wife). (Courtesy of the Harvard Art Museums/Fogg Museum, Harvard University Portrait Collection, Gift of Arthur Rotch, to Harvard University for the Arnold Arboretum, 1958, H574.)

Two

Forming the Arnold Arboretum

Benjamin Bussey's gift of his estate in Jamaica Plain and James Arnold's large monetary bequest were combined to create the Arnold Arboretum in 1872. It would not be until 1873 that Charles Sargent was chosen to be director. Almost immediately he invited Frederick Law Olmsted, the designer of New York's Central Park, to come and look over the landscape. Over the next several years they worked closely together to devise a road system to carry visitors around the grounds and planting arrangements, which took into account the botanical sequence devised by George Bentham and Joseph Hooker. In order to serve the dual purpose he believed the arboretum would have, Sargent had to persuade the City of Boston and Harvard College to undertake a joint financial venture. His motives were not entirely altruistic; he needed additional money to build and maintain the arboretum. Even though the arboretum's nurseries were bursting at the seams, Sargent could not begin work on Olmsted's design without commitment from the city. The negotiations lasted four years. The first city council vote did not pass, prompting Sargent and Olmsted to mount a campaign in the local press to rally support. A public relations drive was launched that had the "Arboretum Question" debated in the city's newspapers. Sargent circulated a petition signed by 1,305 of the most powerful people in Boston. The campaign worked. On December 27, 1882, terms were agreed upon. It took a year to work out the details, but on December 20, 1883, a 1,000-year lease was signed, and an unprecedented agreement between the City of Boston and Harvard College began.

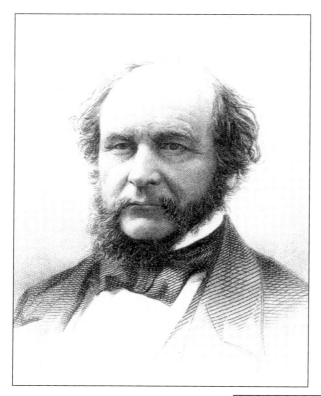

George Emerson was a noted teacher and botanist, but more important for the history of the arboretum, he was also James Arnold's brother-in-law and one of his estate executors. He had worked carefully with Arnold to craft his will and bequests, and it was through Emerson's affiliation with Harvard University that he was able to join Arnold's money with Bussey's land to create a viable institution.

Francis Parkman (1823–1893) is best known for his work as an historian, but perhaps less well known was his expertise with plants. He was a professor of horticulture at the Bussey Institution but resigned in 1872 due to ill health. He may have suggested his young neighbor Charles Sargent as a possible replacement. Sargent took over that position in May that year and became curator of the new arboretum the next month.

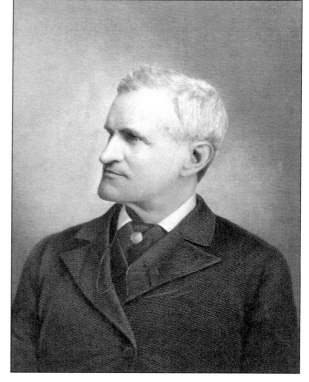

Charles Sargent is pictured here in Paris in 1868. He was born in Boston, Massachusetts, to an old Brahmin family and graduated from Harvard University in 1862. He served in the Union army in the Civil War and was brevetted major by the end of the conflict. From 1865 to 1868 he toured the gardens of Europe and then returned to Boston to manage his father's estate in Brookline, Massachusetts. He was appointed director of the Arnold Arboretum in 1873 and guided the institution with a firm hand until his death 54 years later. During that time, he oversaw the design and building of the arboretum landscape, directed a census of the trees of North America, conducted the publication *Garden and Forest*, traveled the world, created a *Silva of North America* in 14 volumes, and engaged collectors to bring back thousands of plants to grow in the Arnold Arboretum.

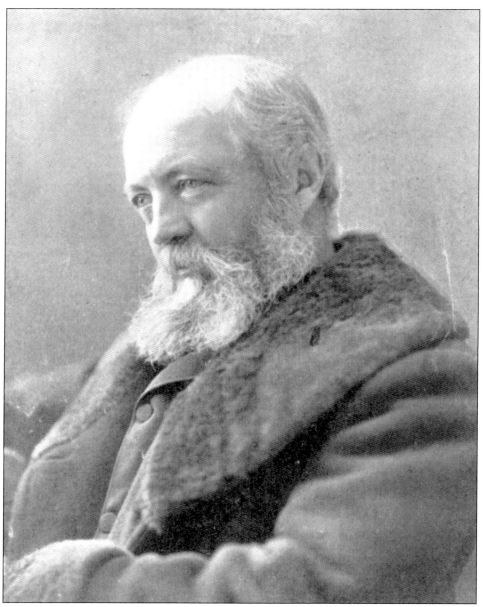

Frederick Law Olmsted is known as the father of landscape architecture. He was born in Hartford, Connecticut, and worked in a number of trades before turning his hand to landscape design. His landscape architecture career began with the design for Central Park in New York City. In 1858, he and Calvert Vaux won first prize for their plan they titled "Greensward." Olmsted's work for the Arnold Arboretum began with a visit to the site in 1874. Production of the design, which included planting plans and road layouts, occurred between 1878 and 1885. Additional work by the Olmsted firm was undertaken between 1890 and 1895 to accommodate the acquisition of Peters Hill. The arrangement of the living collections was a collaboration between Olmsted and Charles Sargent based on the Bentham and Hooker system of plant taxonomy. The landscape was intended to be a pleasure ground for the citizens of Boston and an encyclopedic tree museum for scientists. The Arnold Arboretum is the only extant arboretum designed by Frederick Law Olmsted.

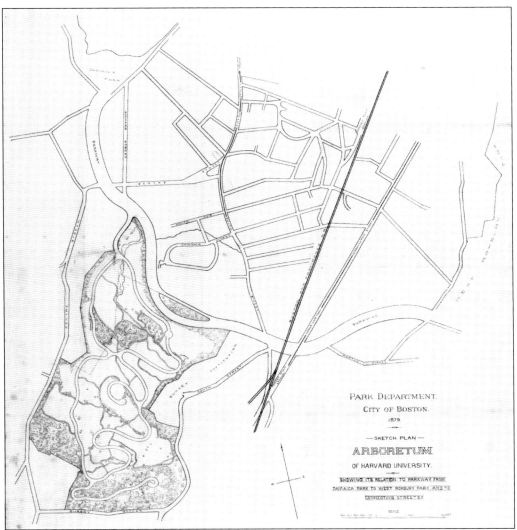

During the late 1870s, Frederick Law Olmsted worked on designs for a road system for the arboretum. He had been charged with creating a circular road but after trying a number of possible designs decided that a continuous road from the north end of the grounds to the south at Bussey Street would be most harmonious with the landscape. Here is one of the circular layouts in a December 1879 plan prepared for the Boston Parks Department, which is radically different from the system as later adopted. Note the northern circuit follows the approximate locations of Willow and Linden Paths today, while the southern circuit approaches Bussey Hill from the east and meanders through the area occupied by the oak collection, finally climbing to the summit of Hemlock Hill. This plan is also notable because it shows the as yet unbuilt Arborway, which is labelled "Parkway" on this map.

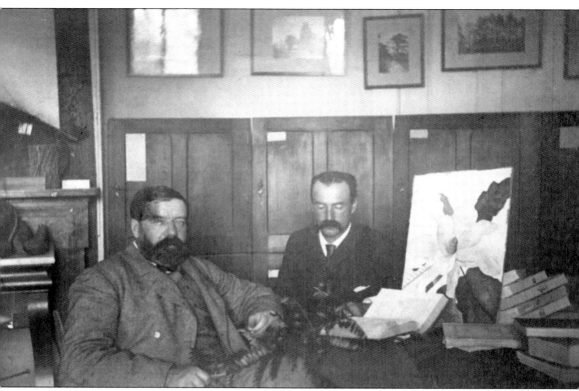

Charles Sargent (left) and Charles Faxon (right) are pictured here at the Arnold Arboretum offices at Dwight House on Sargent's Brookline, Massachusetts, estate in 1880. From 1873 until the construction of the Hunnewell Building in 1892, Sargent conducted arboretum business from Dwight House. The structure also housed the library and herbarium. In this photograph, one can see wooden cases lining the rear wall. Those same cases are still used today by the curation department. Charles Faxon was a lifelong resident of Jamaica Plain whose family was in the shoe-leather trade in Boston. He attended the Lawrence Scientific School in Cambridge, graduating in 1867 with a degree in civil engineering. He was an instructor in botany at the Bussey Institution from 1879 to 1884. Sargent asked him to join the arboretum staff in 1882 as the curator of the herbarium and to oversee the library. He was also engaged to provide the illustrations for Sargent's *Silva of North America*, for which he produced 644 drawings.

Some of the earliest photographs of the arboretum grounds were taken by the Boston Parks Commission to document the progress of construction of the roads and other infrastructure. Here, workers with a horse and cart stand on the extension of Valley Road at the South Street entrance in spring 1889.

The summit of Bussey Hill is nearly devoid of large vegetation in this August 25, 1889, image by a Boston Parks Commission photographer. As part of the original agreement between Harvard and the City of Boston, the city reserved several areas on the grounds for its own use. The parcel on Bussey Hill did not come into the Arnold Arboretum lease until the 1890s, with the acquisition of Peter's Hill.

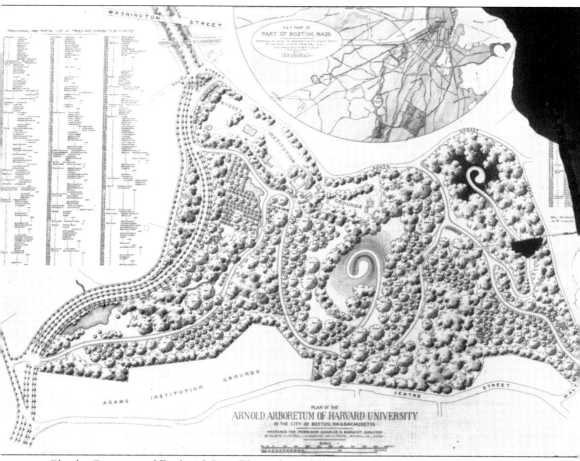

Charles Sargent and Frederick Law Olmsted carefully planned the locations where all the groups of plants would be placed on the grounds. In this design, which is aligned with north on the left side of the image, one can see the road system in its final configuration, with the exception of the road to the top of Hemlock Hill. Starting on the left is a pond where Goldsmith Brook presently flows and the North Meadow is planted nearly completely with trees. Beyond are the neatly arranged rows of the shrub collection and a single large pond, instead of the three that occupy the space today. The reservation on the top of Bussey Hill is clearly evident, and at the center top there is the outline of Benjamin Bussey's mansion. This plan was probably drawn in late 1885 and might have been used in the spring of 1886 for the first planting of arboretum nursery–grown trees, shrubs, and native herbaceous plants on the grounds.

During the early days of the arboretum, Charles Sargent was busy with a number of ventures. Through the influence of Asa Gray and George Emerson, he surveyed the state of America's forests for the government in conjunction with the 10th census of the United States. He is seen here on the left in 1880 with his collaborators, Francis Skinner (center) and George Englemann (right).

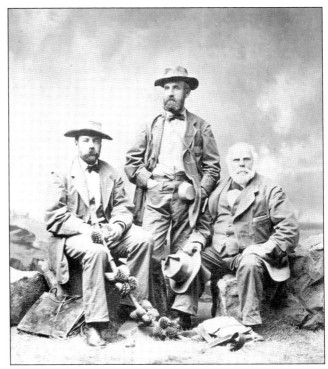

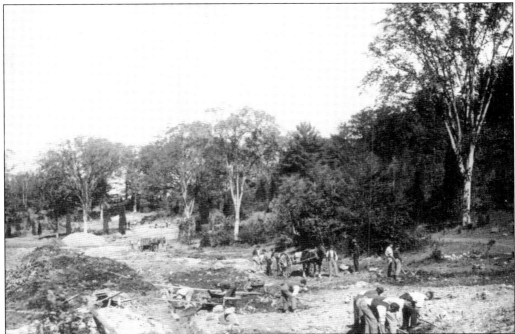

Pictured here are gangs of laborers at work building Hemlock Hill Road near the Walter Street Gate on October 2, 1889. As originally conceived by Olmsted, this road would have passed closer to Bussey Brook, but it was moved farther south to hug the foot of Hemlock Hill and provide access to, in Sargent's opinion, "the most picturesque and attractive part of the Arboretum."

Bussey Hill is pictured here in early October 1890 under construction. Wooden stakes have been placed as markers, perhaps for a roadbed, and the ground has been plowed to break up the turf and make it easier for laborers supplied solely with hand tools to move the soil.

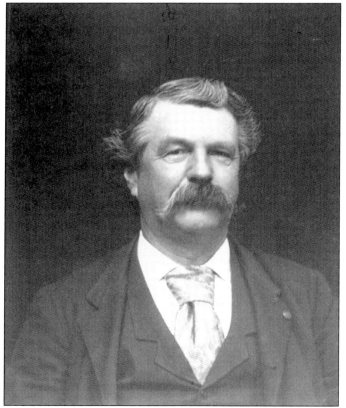

Jackson Dawson was born in England but came to America as a child, settling in Andover, Massachusetts. There he trained with an uncle in the nursery trade and later enlisted in the Union army during the Civil War. After the war, he was engaged as plant propagator by Charles Sargent and became the first employee of the newly formed Arnold Arboretum.

Bussey Hill is pictured here from a vantage point near the Arborway. This photograph from October 15, 1890, shows the openness of the landscape before the lilac collection was planted. In the center one may see the completed Meadow Road and the beginnings of Bussey Hill Road on the left. The narrow dark line of plantings that stretch across the image just above center are the remains of Bussey's lilac hedge.

John Jack was born in Chateauguay, Quebec, to a farming family. He approached Charles Sargent in 1886 about a job at the arboretum, and Sargent set him to work laboring on the grounds. His superior botanical and horticultural knowledge soon became apparent, and he was given greater responsibilities. Jack was a gifted teacher and for many years conducted popular field studies for the public.

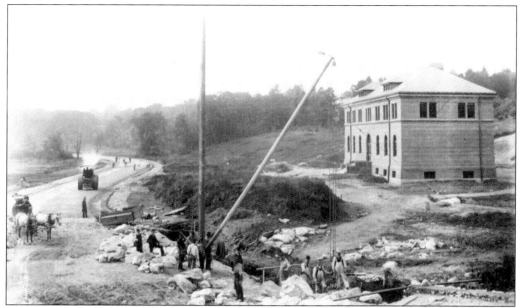

In this summer 1892 photograph by the Boston Parks Commission, city workmen can be seen constructing Meadow Road. With the exception of the steam-powered tractor seen in the left of the photograph, all the early work in the creation of arboretum roads was manual. The newly completed Hunnewell Building is pictured here on the right.

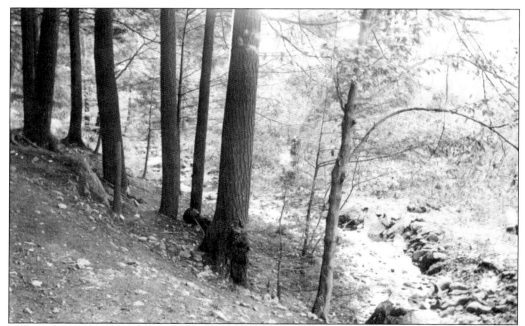

This is a placid scene of eastern hemlocks (*Tsuga canadensis*) beside Bussey Brook at the foot of Hemlock Hill taken by a Boston Park Commission photographer on October 14, 1892. By this date, the majority of the infrastructure such as roads and walls had been completed, and the public could reach all parts of the landscape for study and recreation.

The firm of Olmsted, Olmsted, and Eliot Landscape Architects, the successor company after the retirement of Frederick Law Olmsted Sr., designed these highly ornate wrought-iron gates for the arboretum in 1894 for mounting on the tall granite posts the City of Boston had placed at each of the entrances. However, a more conventional design was installed instead.

In 1888, Charles Sargent began to publish a weekly journal titled *Garden and Forest*. He delegated editing and production to William Stiles (1837–1897), who had many years' experience as a journalist in New York. It was an unofficial organ of the arboretum and also a forum for some of the foremost writers of the day on the environment, park development, conservation, gardens, and forestry. It ceased publication in 1897.

The Neo-Gothic Bussey Institution building is pictured here from South Street about 1895. The building, designed by Peabody and Stearns, was constructed in 1871. It housed the Harvard undergraduate program in horticulture and agriculture, which was originally endowed from a portion of Benjamin Bussey's bequest to Harvard University. In 1908, the school was converted to a graduate program in the applied sciences, with an emphasis on the study of genetics and plant anatomy. A generation of Asian students of botany matriculated through the Bussey Institution and studied with arboretum instructors, including John Jack. Many returned to their homelands to become leaders in their fields. The program closed in the 1940s, and the property was assumed by the Massachusetts Diagnostic Laboratories. The Bussey Institution building burned in 1970 and was torn down. The current Massachusetts State Laboratory building was erected in 1972.

Three

Around the Arnold Arboretum

The 281 acres of the Arnold Arboretum can be traversed by a continuous winding road. Beginning in the northernmost portion of the landscape at the Arborway Gate and the Hunnewell Building, passing the North Meadow on the left, the Bradley Rosaceous Garden, the ponds, and up the hill by the lilac collection, one might pause to catch a breath and consider a visit to the Leventritt Shrub and Vine Garden or the Larz Anderson Bonsai Collection before continuing up to the top of Bussey Hill. After surveying the Boston skyline from this vantage point, and strolling through the Explorers' Garden, one can resume walking along Valley Road to the Spring Brook, home to native peoples thousands of years ago. Look up, and one will see Hemlock Hill rising above. At the fork in the road, a left-hand turn will take visitors out to the South Street Gate and on to the Bussey Brook Meadow, an urban wild, and the newest part of the arboretum. If instead one turns right from Valley Road onto Hemlock Hill Road, the walk will continue along Bussey Brook with the conifer collection on the right and the hemlock forest on the left. In a short distance, one will reach the Bussey Street Gate. Across the road is Peter's Hill. Follow this road as it gently curves, and one will see crabapple trees, hawthorns, and magnificent conifers. At the top of the hill, look toward Walter Street and one will see the old burying ground and the site of the Second Parish of Roxbury meetinghouse built in 1711. At the summit, the second highest point in the city, one can see all the way to the skyscrapers of downtown Boston and beyond to the Harbor Islands.

The open Arborway Gate bids visitors to come and explore the Arnold Arboretum. In this fall 1917 photograph by A.A. Greenlaw, Meadow Road stretches out ahead with lush vegetation on either side. Trees that had been planted out in the mid-1880s are by this date beginning to reach their mature heights.

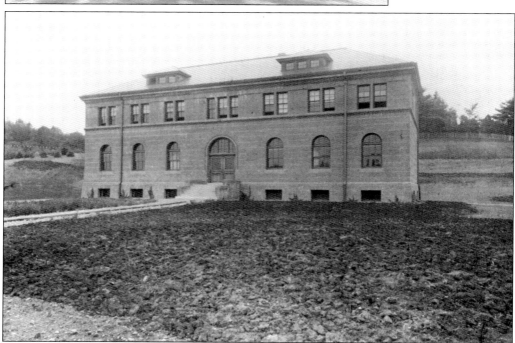

Just inside the Arborway Gate is the Hunnewell Building, seen here in 1892. The building was designed to house the museum functions of the arboretum, herbarium (collection of dried plant specimens), library, and administrative offices. It had just been completed, but the grounds around it had yet to be landscaped. Charles Sargent's cousin Horatio Hollis Hunnewell (1810–1902) provided $30,000 in funding to build the structure, which was designed by Longfellow, Alden and Harlow, architects. Its style was influenced by the designs of Sargent's late friend, Henry Hobson Richardson (1838–1886), whose final resting place is next to Sargent in Brookline's Walnut Hills Cemetery.

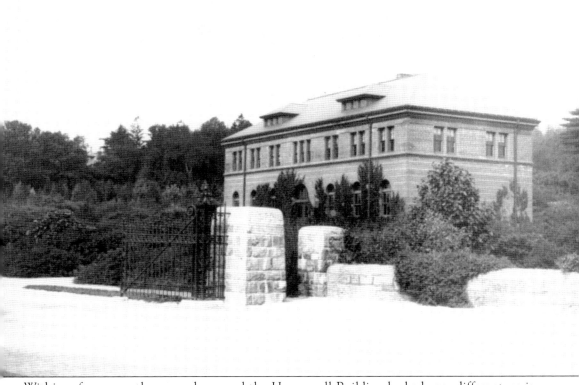

Within a few years, the grounds around the Hunnewell Building looked very different, as is evidenced by this June 1899 photograph by arboretum taxonomist Alfred Rehder (1863–1949). Broken soil has been replaced by densely placed shrubs and young trees. The massive granite gateposts now feature heavy wrought-iron gates, which had been installed by the city the previous summer. They were of a more conventional style than the florid design proposed by the Olmsted firm. This building served the institution well, but soon the growing library and herbarium necessitated more space. In 1909, a four-story addition was added to the rear of the building. It was designed with large windows and a central open atrium, which brought light into the middle of the structure, an important feature, as the building was not electrified until 1929.

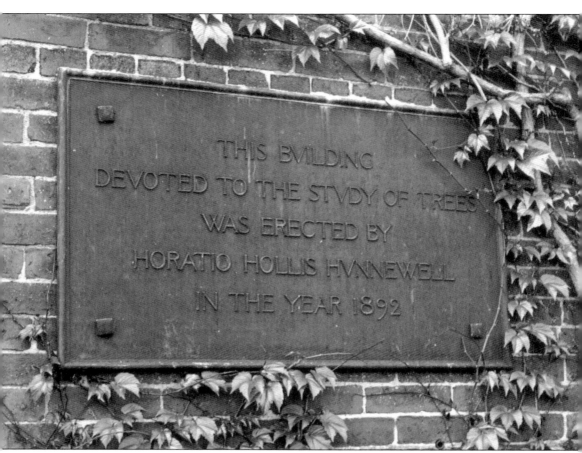

This bronze plaque hangs beside the main entrance of the Hunnewell Building. Horatio Hunnewell was a financier, railroad executive, and philanthropist. Like a number of other prominent Massachusetts men of his time, he was also passionately devoted to horticulture, having raised his first trees for sale before he was 15 years old. On his large estate in Wellesley, Massachusetts, he planted an extensive Italian garden, was an early cultivator of rhododendrons in America, and created a noted pinetum. He served as vice president of the Massachusetts Horticultural Society from 1864 to 1874 and served on many of its committees. Hunnewell supported the development and work of the Arnold Arboretum from its founding and was an extremely generous benefactor for nearly 30 years, providing the funds to build the Hunnewell Building as well as contributing to arboretum collecting expeditions.

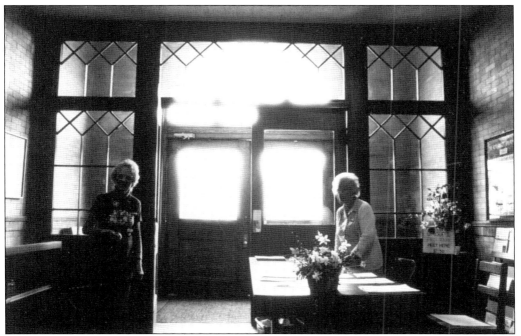

The foyer of the Hunnewell Building has welcomed visitors to the arboretum since the structure was opened in 1892. Over the years, it has been a meeting place for tours and a place to find out which trees are in bloom. Here, two volunteers greet visitors around 1980, prior to the complete renovation of the building in 1993.

The first floor of the Hunnewell Building contains two large rooms in the front portion of the structure, which have been used over the years as exhibit and lecture halls as well as additional library space. The rear part of the building, the 1909 addition, housed offices. It is pictured here in the spring of 1919 stacked high with newly arrived plant specimens from Korea.

The second floor of the building houses the herbarium, seen here in a 1927 photograph by botanist Jan Bijhouwer (1898–1974). A herbarium is a collection of pressed dried plant specimens mounted onto sheets of heavy paper. They are used by botanists to conduct research on plants, but they also can preserve genetic material and provide data on flowering or fruiting dates over time.

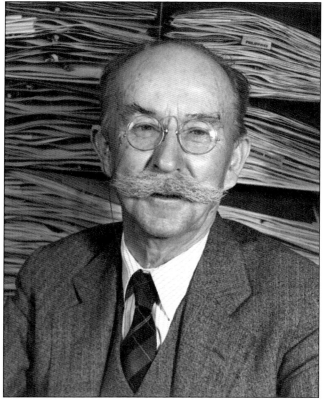

Alfred Rehder poses before an open herbarium case in 1939. Rehder came from a family of gardeners and trained in the nursery trade but later turned to horticultural writing. He came to America in 1898 and was hired by Charles Sargent to work on the grounds. He later headed the herbarium and was editor of the *Journal of the Arnold Arboretum*.

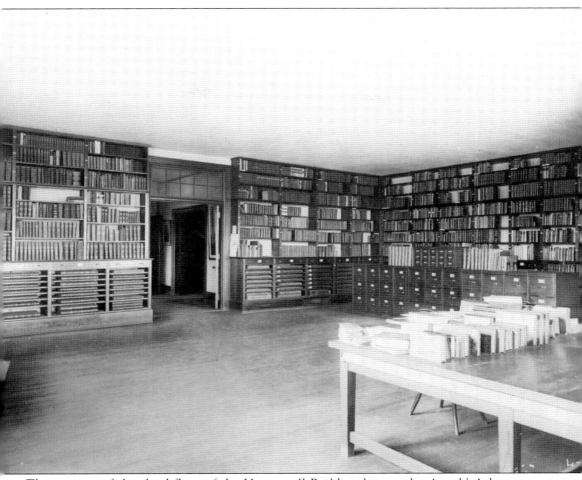

The entirety of the third floor of the Hunnewell Building houses the Arnold Arboretum Horticultural Library and Archives. The reading room is seen here in January 1924. The library dates to the earliest days of the arboretum in the 1870s, when Charles Sargent began to buy books and pamphlets to aid his work. He housed his growing collection at his Brookline estate, Holm Lea. The early books were primarily technical in nature, including titles in dendrology, horticulture, North Temperate Zone floras, and plant monographs. When the Hunnewell Building was constructed in 1892, he donated the 5,000 books and 5,500 pamphlets he had collected to the institution along with a small endowment for their upkeep. Sargent ensured the continued growth of the library by continuing to give generously himself and arranging for gifts from donors who shared his interests in trees, horticulture, and public landscapes.

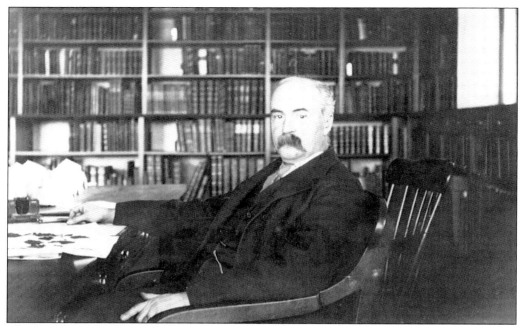

Charles Faxon is pictured here in the reading room in 1903. Early in his life he developed a love for nature and a keen intellect, which led to dedicated scientific inquiry. He was also an accomplished artist, and his botanical drawings are considered masterpieces of their art. He joined the arboretum staff in 1882 as the curator of the herbarium and head of the library.

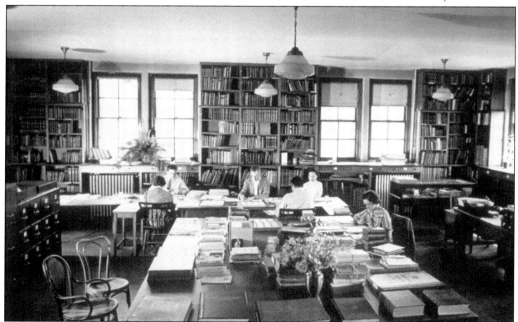

Pictured here is the library reading room in the late 1940s with arboretum scientists at work. In the center of the photograph is a large wooden table, which was built in place when the structure was constructed. To the left are filing cabinets containing mounted photographs of trees. At the rear table, the botanists appear to be examining plant material and writing specimen labels.

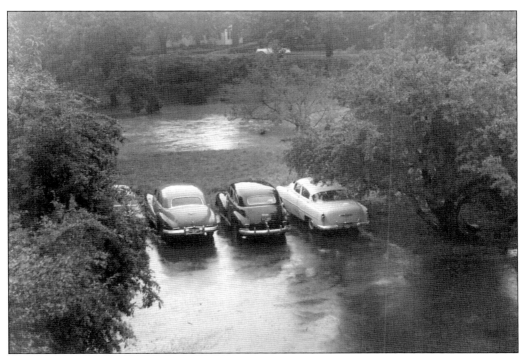

Goldsmith Brook flows beside the Hunnewell Building, under the Arborway Gate, and into the North Meadow. In this August 1955 photograph by Heman Howard, it is swollen with heavy rains and has risen nearly three feet, threatening to overflow its banks and flood the parking lot.

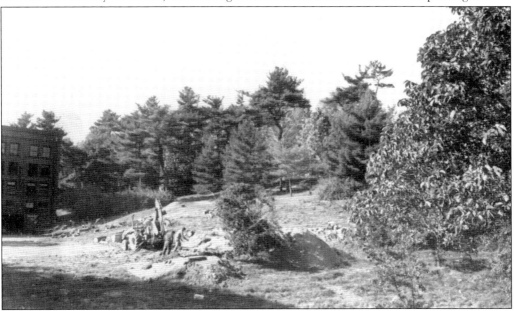

By the late 1960s, more and more equipment was being employed for grounds maintenance. In the previous decades, all the mowers, sprayers, and chippers were rolled into the basement of the Hunnewell Building each evening. In November 1967, construction began on a garage next to the building. Pictured here is a front-end loader just beginning the excavation.

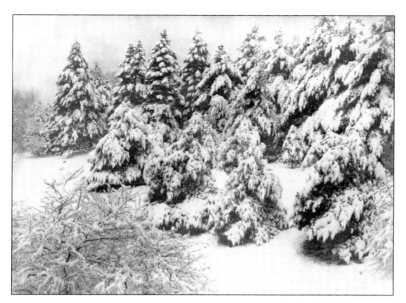

Ernest Wilson photographed this stand of conifers behind the Hunnewell Building heavily blanketed in snow in the winter of 1919–1920. In his diary, John Jack recorded that on February 5 and 6, 1920, a blizzard stopped the trains and stranded arboretum employees at home. This image may record the results of this massive storm.

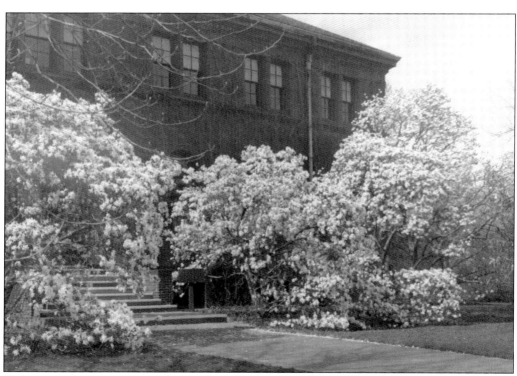

Early spring brings a spectacular display of Magnolia stellata around the Hunnewell Building, pictured here on May 1, 1955. The plantings are arranged by the 19th-century classification system devised by George Bentham and Joseph Hooker for their Genera Plantarum. The sequence begins with the magnolia family around the Hunnewell Building and progresses through the grounds following the road system.

Opposite the Hunnewell Building lies the North Meadow, seen here in a 1915 photograph by George R. King. In the background are willows (*Salix*), the only genus of plants in the arboretum radically moved out of their Bentham and Hooker sequence. The meadow is naturally damp and provides a good growing environment for these water-loving plants.

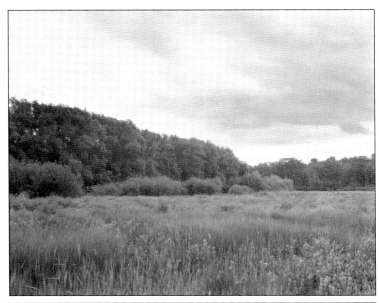

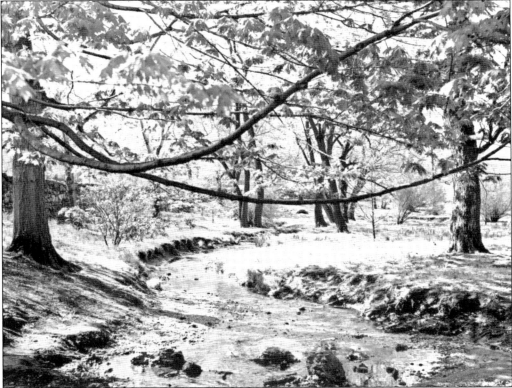

Goldsmith Brook, seen here in a 1970 photograph by Pamela Bruns, flows through a culvert by the Arborway Gate and into the North Meadow before exiting the arboretum through another culvert under the Arborway. Charles Sargent spent many years trying to fix the drainage problems in this part of the arboretum by excavation and installation of drainage tiles, but excessive dampness and flooding continued to effect the area.

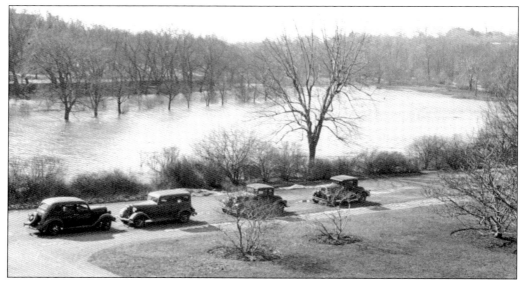

Sometimes in the spring or late fall, heavy rains will cause the North Meadow to flood, turning the area into a temporary lake. This happened on March 12, 1936, as seen in this photograph by Donald Wyman taken from a vantage point on the third floor of the Hunnewell Building. In the background on the left, the Arborway curves on its way to Forest Hills.

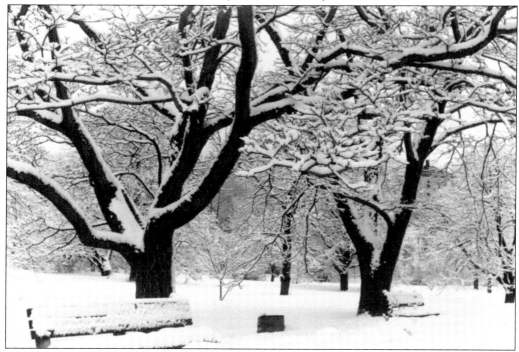

The cork tree (*Phellodendron*) collection is blanketed in deep snow on February 2, 1966, following the blizzard that struck the Northeast between January 29 and 31. Boston received about a foot of snow on top of the accumulations from two other storms over the previous several weeks. Residents of Central New York were not as lucky, with some areas in Oswego County receiving 102 inches of snow from the storm.

Leiteneria Path is pictured here from Meadow Road leading to the horse chestnut (*Aesculus*) collection with the trunk of a large northern red oak (*Quercus rubra*) on the left, in the early summer of 1903. Mown grass paths were first created on the grounds in the 1890s and expanded in 1903. They allowed increased visitor access from the main roads into the more remote areas of the collections.

Meadow Road is featured in this photograph from May 27, 1950. On the right are flowering dogwoods (*Cornus florida*) and to the left pinkshell azaleas (*Rhododendron vaseyi*), part of the azalea border plantings designed by the noted American landscape gardener Beatrix Farrand, best known for her designs for the gardens and natural woods at Dumbarton Oaks in Washington, DC.

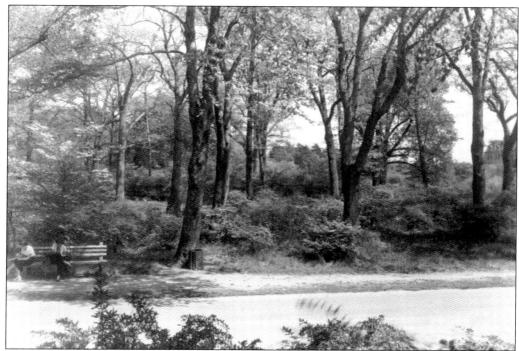

Women relax on a bench along Meadow Road in the spring of 1950 or 1951. Behind them, beneath the dappled shade of oak trees, is a stand of torch azaleas (*Rhododendron kaempferi*). This species, found throughout Japan, bears salmon pink to red flowers. It is named for Engelbert Kaempfer (1651–1716), the German physician and botanist who first described the Japanese flora.

This is a wintery view from Meadow Road looking east, taken in January 1952. The trellises of the shrub collection can be seen in the middle distance. The collection was arranged in rows with the plants in their Bentham and Hooker sequence and proved to be immediately popular from its planting in 1885. Today, it has been relocated and been remade as the Leventritt Shrub and Vine Garden.

This springtime view of the well-ordered rows of the shrub collection was captured on May 7, 1931, by the second director of the arboretum, Oakes Ames. In the background, the florid Bussey Institution building can be seen.

This view of the shrub collection is looking northeast with the Arborway wall in the background. The new white cedar vine trellis was constructed in the winter of 1950–1951. It would be planted with more than 60 taxa of vining woody plants, including wisterias, which had been previously moved to the Bussey Institution grounds. Siting for this trellis may have been suggested by Beatrix Farrand, who did design studies for this collection.

Oakes Ames was appointed supervisor of the arboretum after Charles Sargent's death in 1927. Scion of an old New England family, Ames graduated from Harvard College and later taught at the Bussey Institution and elsewhere in the university. He was an expert on orchids and amassed an extensive herbarium and library, which he donated to Harvard in 1935.

Blanche Ames (1878–1969) was Oakes Ames's wife of 50 years. A graduate of Smith College, she was a gifted botanical artist and often worked with her husband to illustrate the orchids he collected. Here is her drawing of a bract of *Davidia involcrata*, the dove tree. Ames was also a crusader for women's voting and reproductive rights.

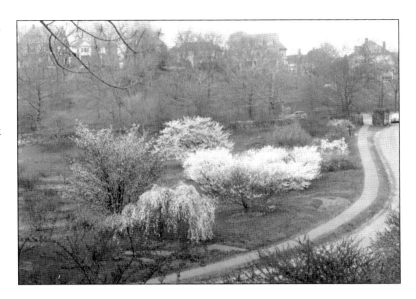

The flowering cherry (*Prunus*) trees by the Forest Hills Gate are pictured here in full bloom on May 5, 1950, with the Arborway beyond. Donald Wyman took this photograph just over a year before construction of the large embankment, which was part of the Casey overpass on the Arborway.

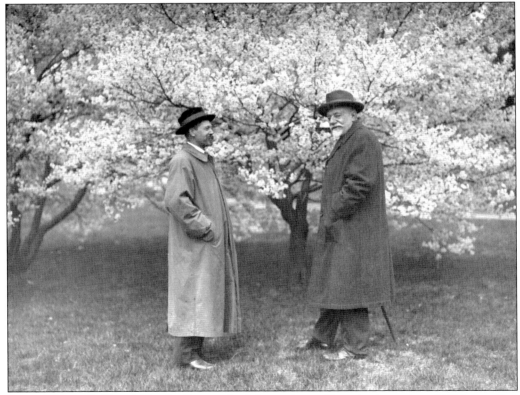

Ernest Wilson (left) and Charles Sargent (right) are pictured here in the spring of 1915, standing beside a Higan cherry (*Prunus subhirtella*), accession number 3674, which was received as a plant from the Imperial Botanical Garden, Tokyo, Japan, on April 17, 1894. Unfortunately, this lovely tree, which was the first of its kind on the arboretum grounds, died in the 1940s.

This view of flowering cherry trees from the Forest Hills Gate with Bussey Hill in the distance was taken on April 27, 1929, by Herbert Wendell Gleason (1855–1937). This photograph includes the decorative iron gates that were installed in early 1899. Today, they are permanently closed to vehicular traffic for the safety of visitors.

Visitors enjoy an early fall day in 1976 beside Dawson Pond. The three manmade ponds clustered along Meadow Road near the Forest Hills Gate are home to aquatic wildlife, including fish, frogs, water fowl, and sometimes snapping turtles. Visitors and their leashed pets should enjoy the beauty of the ponds from the banks, rather than wading in.

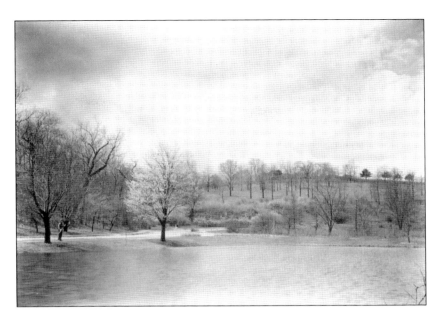

Dawson Pond is brimming with water in late April 1929. This photograph by Herbert Gleason shows the relative height of Bussey Hill quite well. From its heights, visitors can have a commanding view of the Blue Hills Reservation to the southeast.

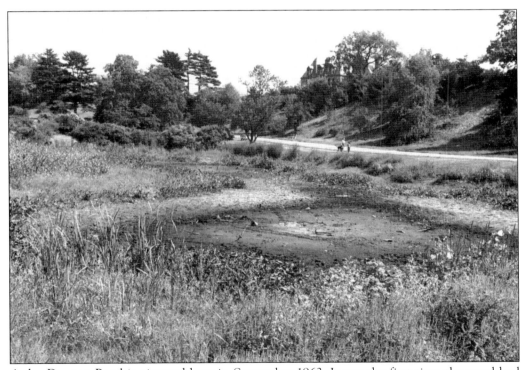

A dry Dawson Pond is pictured here in September 1963. It was the first time the pond had completely dried out since 1957 and only the second time in the previous 35 years that drought conditions had been that severe. Forest Hills Road can be seen in the background, and the Bussey Institution building is in the center back. The photographer was Heman Howard, assistant horticulturist from 1929 to 1970.

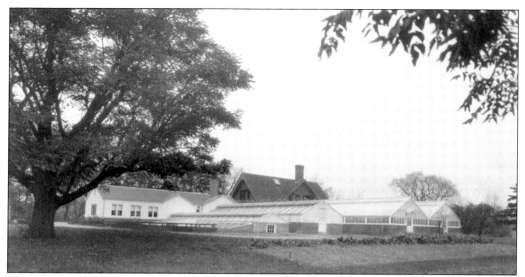

The Bussey Institution once stood overlooking the ponds near the shrub and lilac collections. Arboretum plant-propagation operations were housed there from 1928 to 1962. This November 1928 photograph shows the newly built Lord and Burnham greenhouses and laboratory with the potting shed and gardener's quarters in the background. Note the cultivated beds in the foreground for planting out specimens.

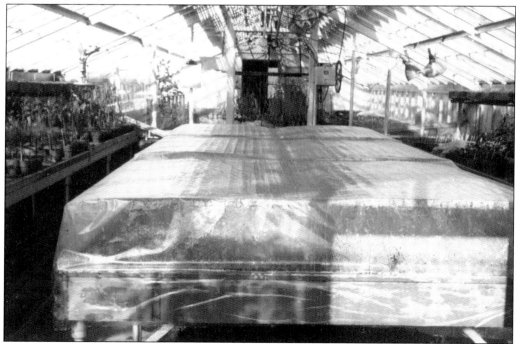

The interior of one of the greenhouses is pictured here in 1955 with a propagation case covered in polythene holding young tender plants. Greenhouse operations raise seeds gathered on plant-collecting expeditions as well as repropagate plants already growing on the grounds. In this way, plants in decline due to age, disease, or weather events may be preserved in a genetically identical clone and raised to replace the failing tree or shrub.

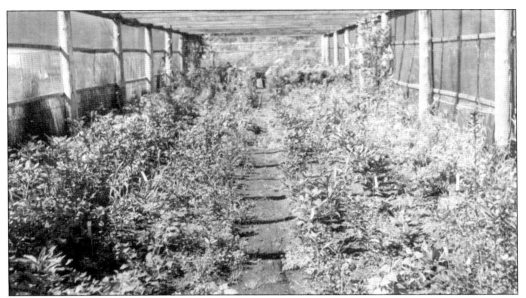

Not all greenhouse operations take place indoors. Under the partial cover of the Saran House, plants that require some shade can grow outdoors. Here in this late 1950s image, plants are growing for eventual planting out on the arboretum grounds.

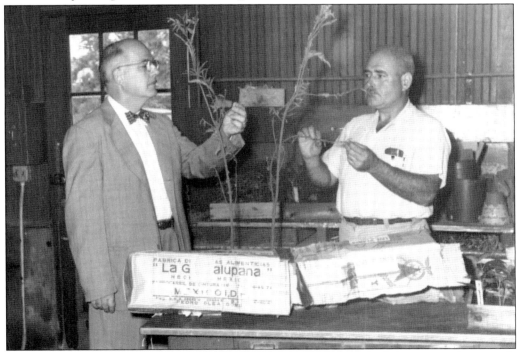

Horticulturist Donald Wyman (left) and propagator Alfred Fordham (right) examine plants newly arrived from Mexico in October 1959. Fordham was born in Roslindale, Massachusetts, and grew up in the nursery trade. He came to work at the arboretum in 1929 as a student trainee and rose to become chief propagator before retiring in 1977. He received the International Plant Propagators Society Award of Merit in 1971, given for significant achievements in propagation.

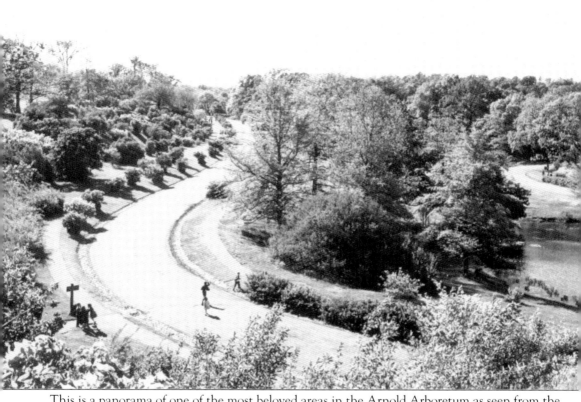

This is a panorama of one of the most beloved areas in the Arnold Arboretum as seen from the rise of the Bussey Institution grounds (now the Massachusetts Diagnostic Laboratories) on May 29, 1959. To the left in the photograph along Bussey Hill Road is the lilac collection. The Japanese tree lilac (*Syringa reticulata*), which was accessioned in 1876, can be clearly seen towering over

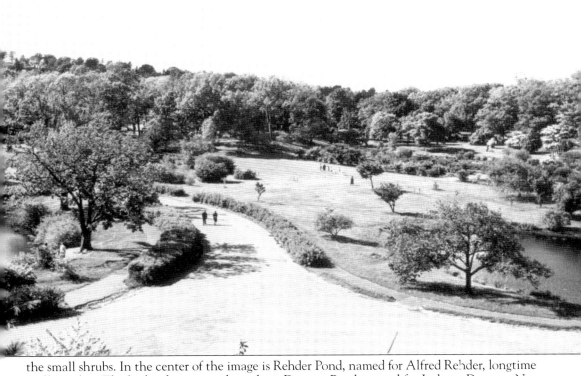

the small shrubs. In the center of the image is Rehder Pond, named for Alfred Rehder, longtime staff member. The body of water on the right is Dawson Pond, named for Jackson Dawson. Not visible in this photograph is Faxon Pond, which is named for Charles Faxon.

The forsythia collection along Bussey Hill Road can be seen in full bloom beyond the placid waters of Rehder Pond in this May 1932 photograph by Herbert Gleason. Gleason is perhaps best known for his photographs of Walden Pond and the countryside around Concord, Massachusetts. Over 100 of his images were used to illustrate the 12-volume 1906 edition of Henry David Thoreau's writings.

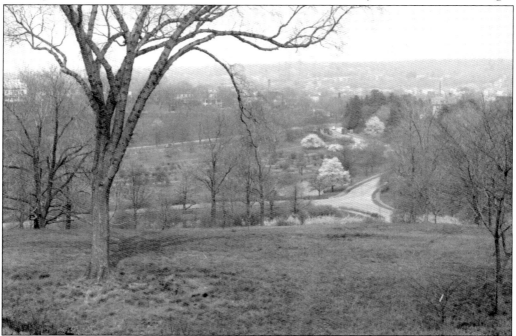

This view of flowering cherry trees, the Forest Hills Gate, and the shrub collection was taken from a vantage point on the northeast slope of Bussey Hill on May 4, 1950. In the background, beyond the borders of the arboretum, the area of Washington Street in Jamaica Plain can be seen. Forest Hills Station is hidden by the wooded rise at center right.

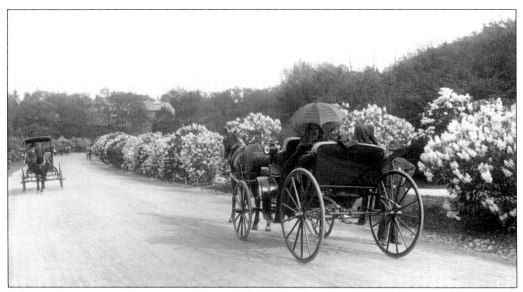

A horse-drawn carriage pauses on Bussey Hill Road before the lilac collection in a photograph by Thomas E. Marr from May 1908. At first, Sargent was not sure that these "showy flowered garden shrubs" should be planted there, fearing that "they would not harmonize with the general scheme of planting we have adopted." He has been proven wrong; the collection has become one of the most popular in the arboretum.

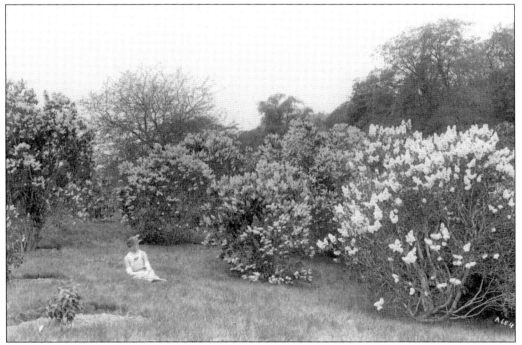

A woman sits in the midst of the lilac collection to enjoy the abundant blossoms in this May 31, 1926, photograph by Ernest Wilson. That year they were especially floriferous, but the decision was made to cut them back quite extensively after flowering to help rejuvenate the plants. In the spring of 1927, there were no lilacs in bloom.

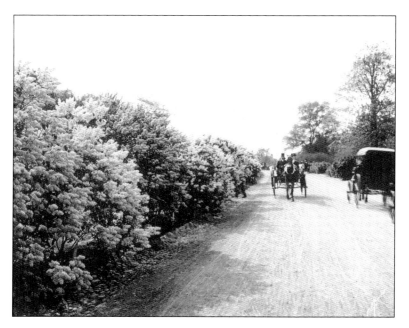

For well-heeled visitors in the early 1900s, carriages were the preferred mode of seeing the arboretum. Photographer Thomas E. Marr captured these trotting past the lilac collection on May 23, 1908. The lilacs still delight visitors, especially on Lilac Sunday in May, when 40,000 or more people come to see and enjoy these fragrant flowers.

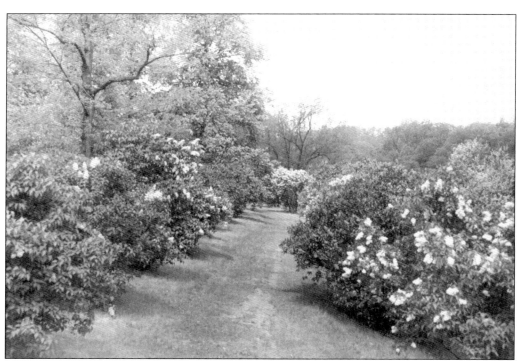

Lilacs are coming into bloom on the upper path through the lilac collection in this photograph taken about 1951. Global warming is directly observable in the arboretum collections by comparing the dates of historical photographs with current bloom times. The flowering trees and shrubs bloom approximately two weeks earlier today than a century ago.

Two women walk on a path in the North Woods in a May 1973 photograph by Pamela Bruns. This undulating part of the landscape had been clear-cut in the Colonial period but had been allowed to return to woods during Benjamin Bussey's ownership. It is a landform known as an esker, a ridge composed of gravel and sand laid down during the last ice age.

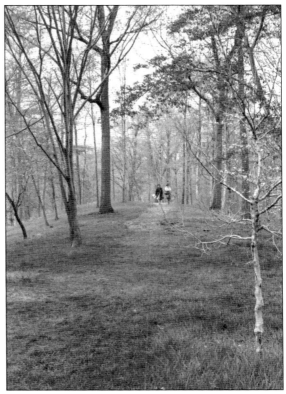

This is the earliest known view of arboretum plant-propagation operations, taken about 1895. It not only housed the nursery beds and greenhouse, but was also the home of Jackson Dawson and his family. It was here that he raised all the seed that Ernest Wilson and others brought back from China. In total he grew 450,718 plants during his 43 years as arboretum propagator.

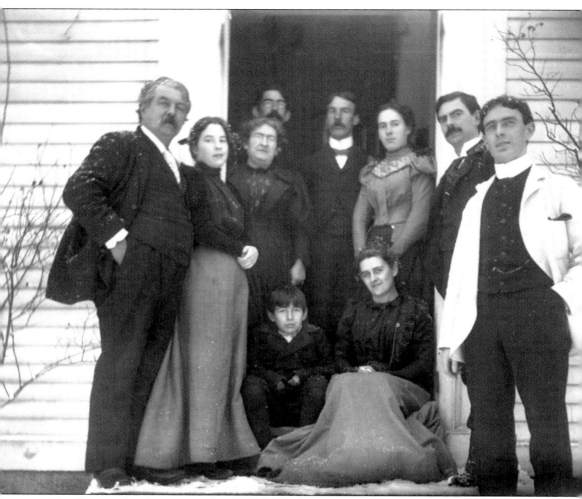

The Dawson family poses at the front door of their home around 1895. From left to right are (seated) Henry Sargent "Harry" Dawson (son) and Julia Elizabeth Hoffman Dawson (wife of William Francis Dawson); (standing) Jackson Dawson, Laura Blanchard Dawson (daughter), Bessie Minnie Dawson (wife), George Walter Dawson (son), Charles Jackson Dawson (son), Minnie Motley Dawson Blossom (daughter), William Francis Dawson (son), and James Frederick Dawson (son). Many of the Dawson children became notable practitioners in the horticulture and landscape-design fields and engaged in artistic pursuits. The eldest son, William, an engineer by profession, was also a gifted photographer. George was an artist who taught at the University of Pennsylvania. Charles ran Eastern Nurseries along with his sister Minnie and later with brother Henry. Laura was an instructor at the Lowthorpe School. James was a landscape architect who worked for the Olmsted firm. The house was originally built about 1800. It passed through several owners and was leased from the Adams Nervine Asylum in 1886 for use as a nursery and residence.

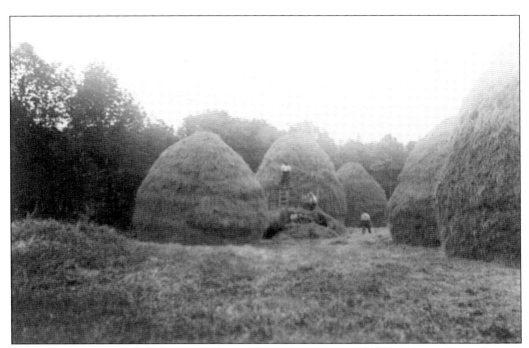

Ernest Palmer captured this image of haystacks in the summer of 1931. During the early years of the arboretum, hay was still grown on the grounds for profit and also for use in horticultural applications. These haystacks were located on the gently sloping area that today houses the Leventritt Shrub and Vine Garden.

Meadow Road is pictured here with fragrant sumac (*Rhus aromatica*) in the foreground and the Adams Nervine Asylum house in the background. The Adams Nervine was groundbreaking in its use of a home-like setting for the treatment of mental illness. The building in this photograph was constructed by J. Gardiner Weld about 1875.

In the late 1950s, the decision was made to move greenhouse operations back from the Bussey Institution to a location in the arboretum. This May 1960 photograph shows the proposed parcel next to the Centre Street house, the site of the first arboretum nursery on the grounds. Today, the Dana Greenhouses share this site with the Leventritt Shrub and Vine Garden.

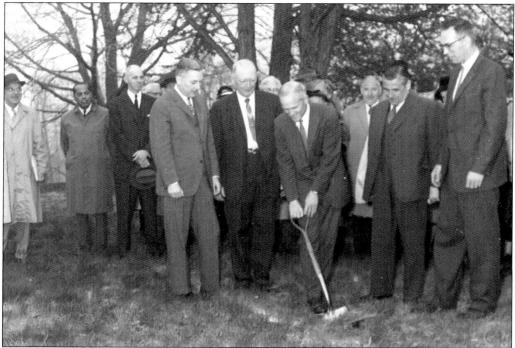

Ground was broken for the Dana Greenhouses on May 12, 1961, in a ceremony attended by many dignitaries. From left to right are (first row) Nathan Pusey (Harvard University, president), Martin Walsh (Boston Park Commission), Bradford Washburn (Boston Museum of Science, director), George Taylor (Kew Gardens, England, director), and Richard A. Howard (Arnold Arboretum, director); (second row) Donald Wyman, D.M.A. Jayaweera, Chester E. Bond (contractor), and unidentified.

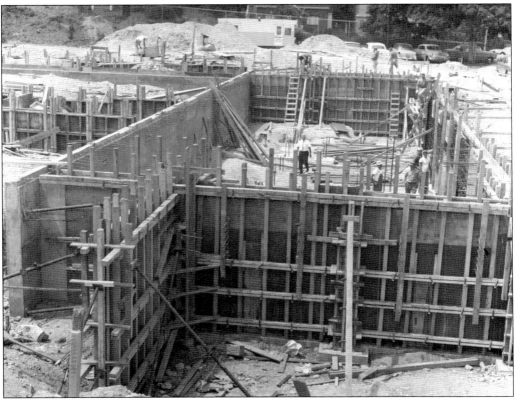

Work began on the Dana Greenhouses immediately following the ground-breaking ceremonies. By July 11, 1961, the wooden forms were in place, ready to be filled with concrete for the foundations of the main building of the complex. This photograph shows the large size of the basement.

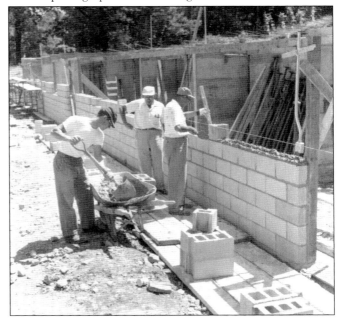

The aboveground walls of the Dana Greenhouse buildings were constructed of bricks or cement blocks. Here, on August 1, 1961, masons can be seen laying one of the walls of the cold-storage building while another man mixes some mortar in a wheelbarrow.

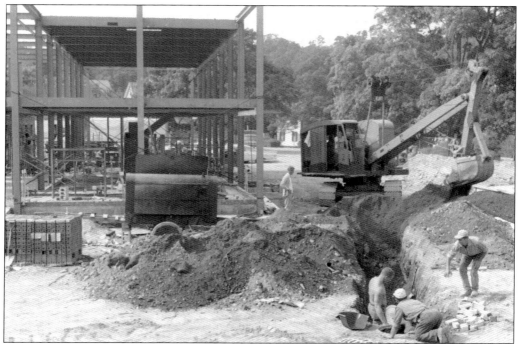

Construction continued on the Dana Greenhouses through the summer, and by September 19, 1961, the steel framework of the main building was in place. Here, workers are in a trench that would soon be used for electric lines.

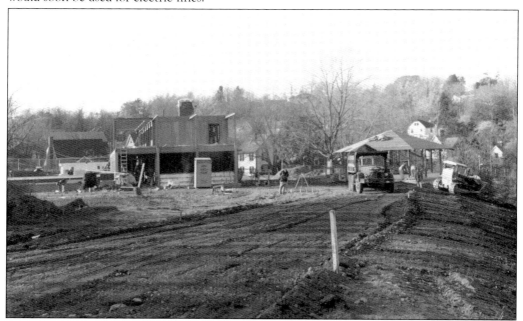

By the end of 1961, construction of the Dana Greenhouses was well along, and the framework for the lath house for the Larz Anderson Bonsai House was also in place. In this photograph dated November 10, 1961, workers can be seen surveying and grading the area in preparation for the installation of the nurseries in the spring of 1962.

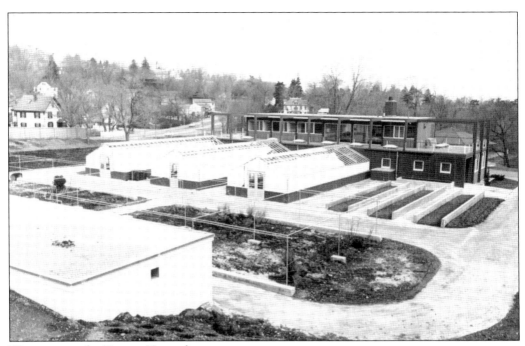

This is a view by Heman Howard, looking north, of the newly completed Dana Greenhouses complex in May 1962. The cold-storage unit is the low structure with the flat roof on the left, the three greenhouses are at the center, and the Dana Greenhouses Head House building is at the rear. Centre Street can be seen on the upper left.

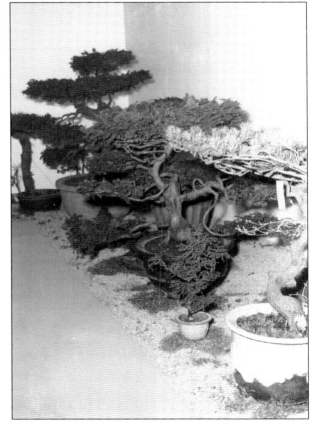

Plants from the Larz Anderson Bonsai collection are pictured here in the newly constructed cold-storage unit in March 1962. From mid-April to mid-October, the plants are displayed outside in the bonsai pavilion near the Dana Greenhouses. To protect these containerized plants during the cold months, the collection is stored in the concrete-block cold-storage unit and maintained at 33 to 36 degrees Fahrenheit. The plants are checked for water once a week.

Viewing the landscape on horseback was a popular pastime in the earlier days of the arboretum. Here, a man and woman are passing black haws (*Viburnum prunifolium*) along Bussey Hill Road in the vicinity of Centre Street Gate in a June 1903 photograph by Thomas E. Marr.

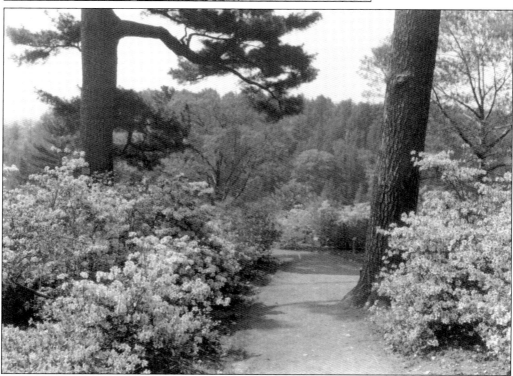

After visiting the Dana Greenhouses and the bonsai, it is a short walk to Bussey Hill. In addition to lilacs, azaleas are also in bloom in spring and early summer. J. Horace McFarland, the noted horticultural publisher, photographed a magnificent display of torch azaleas (*Rhododendron kaempferi*) there in 1928. Native to Japan, this plant can be tender in New England and prefers more protected locations.

Elmer Drew Merrill (1876–1956), the third director of the Arnold Arboretum, is featured in this informal photograph on the steps of the Hunnewell Building in the late 1940s. He was born in Maine and graduated from the University of Maine in 1898. In 1901, he went to the Philippines to work for the US Department of Agriculture. More than two decades later, he returned to America to become dean of the College of Agriculture at the University of California, Berkeley. Merrill moved again in 1929 when he took the reins as director of the New York Botanical Garden. He came to the arboretum in 1935 and saw the institution through the end of the Great Depression and World War II. He actively promoted the collection of tropical plant specimens and, with the appointment of Donald Wyman as horticulturist in 1936, expanded the arboretum's role in the promotion of home gardening.

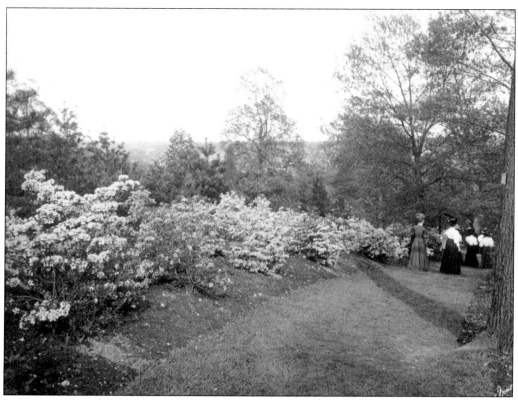

Japanese azaleas (*Rhododendron kaempferi* and others) in bloom are pictured here on May 23, 1908, along Azalea Path on the southwestern slope of Bussey Hill. The planting was quite new when Thomas E. Marr took this photograph, having been moved there from the overcrowded shrub collection the previous year. Charles Sargent lamented that "the plants are fully exposed to the sun and the flowers, which are extremely delicate, soon wither."

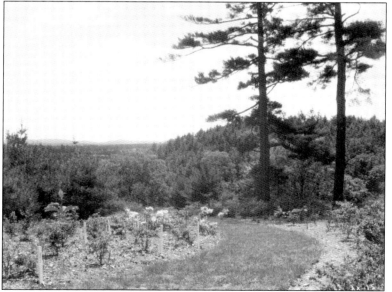

As a result of Ernest Wilson's collecting expeditions to Asia, many new plant species were introduced to the arboretum. In this 1916 photograph by George R. King are beds newly planted with flowering shrubs, some of which may have grown from seeds collected by Wilson. The peaks of the Blue Hills can be seen in the far distance.

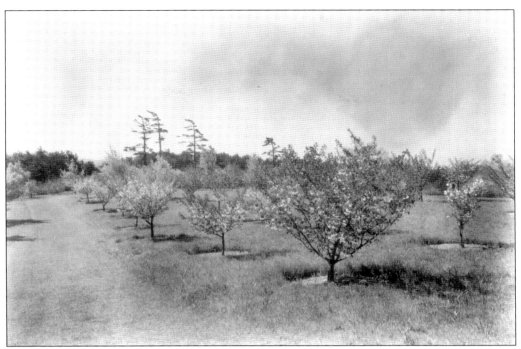

In May 1929, Herbert Gleason photographed the overlook area on the eastern side of Bussey Hill, which had been planted with Ernest Wilson's collection of flowering cherry trees. Wilson would have liked his collection to have rivaled those in Washington, DC, or Rochester, New York, but there was not enough room on the arboretum grounds to accommodate them. This collection was removed from this location in the 1940s.

In the early 1970s, the landscape at the summit of Bussey Hill was renovated. Excess blacktop was removed, erosion controls implemented, and steps were installed in areas that visitors had habitually used as cut-throughs. Staff photographer Pamela Bruns documented the new landscaping in this photograph from the spring of 1974.

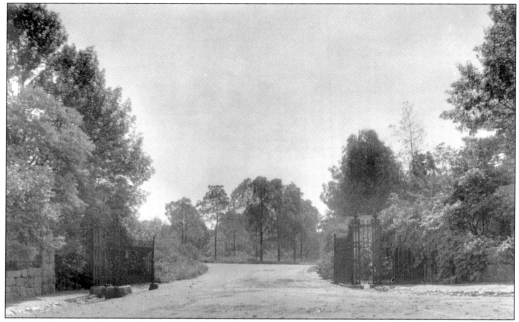

Pictured here is the Centre Street Gate, with the intersection of Bussey Hill Road and Valley Road beyond. In the early years, the road surfaces in the arboretum were made of finely crushed packed gravel edged with cobblestone gutters. This provided an even surface for carriages and visitors on horseback.

Trees in the oak collection pruned about 10 years previously using the Des Cars method are featured in an 1899 lantern slide by John Jack. This system was adopted by Sargent in the early years to rejuvenate the older existing trees in the landscape. It had the effect of pollarding on the ends of the branches where the cuts were made.

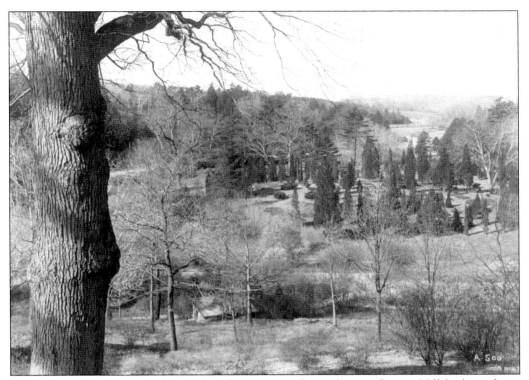

This is a view by Ernest Wilson taken from among the azaleas on Bussey Hill looking down across the oak collection and Valley Road to the juniper collection beyond. This photograph from May 1925 shows a structure in the center-left foreground, which may be a tool shed torn down in 1952.

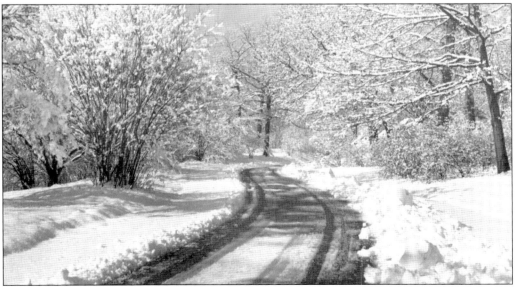

It is a winter wonderland on Valley Road in January 1952. The oak collection can be seen on the right, and Spring Brook may just be made out on the left, blanketed in snow. This section of the arboretum's road system was the first to be completed, opening to carriage traffic in 1886.

Wildflowers carpet the Bussey Brook valley, and large stands of rhododendron can be seen in the background at the base of Hemlock Hill in this June 1908 photograph by Thomas E. Marr. The first rhododendrons were planted out here in 1886 to add to the scenic beauty of the area and test varieties for cold hardiness.

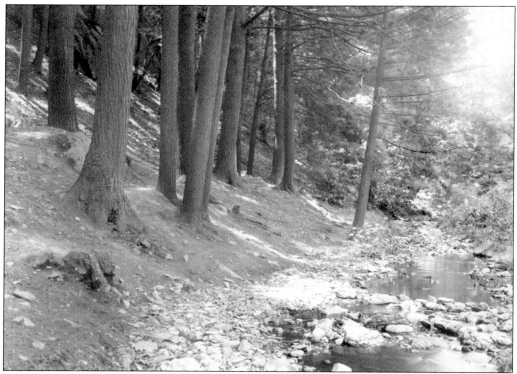

Bussey Brook flows at the base of Hemlock Hill near the South Street Gate in this May 1903 photograph by Thomas E. Marr. Even before the formation of the Arnold Arboretum in 1872, this scenic area was popular with the public for walking and picnicking. Today, picnicking is permitted at the arboretum on one day only each year—Lilac Sunday.

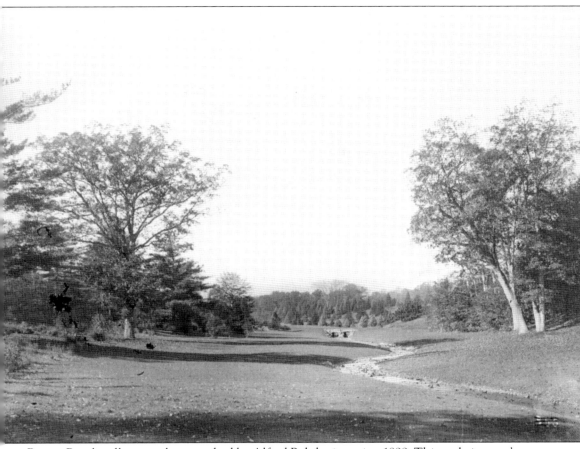

Bussey Brook valley was photographed by Alfred Rehder in spring 1899. This early image shows a landscape with sparser vegetation and younger plantings such as the conifer collection, which can be seen in the center back. The open area in the center of the photograph was a wet alder thicket prior to the building of the arboretum's infrastructure by the City of Boston. Those trees were removed, and the channel of Bussey Brook was deepened. In the spring of 1927, the area was the site of Charles Sargent's memorial service. The leaning white oak on the right side of the photograph was lost in the fall of 1955 after particularly heavy flooding. This image, as well as a number of others in the collection, were taken by Rehder soon after his arrival in America.

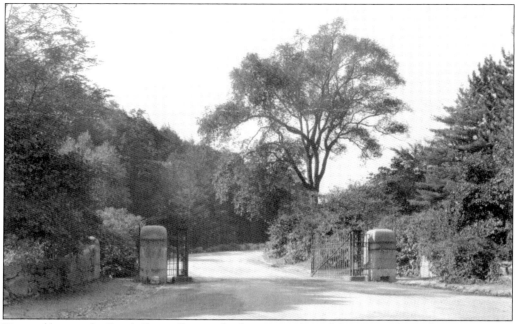

Pictured here is the South Street Gate with a large vase-shaped American elm (*Ulmus americana*) in the background and Hemlock Hill to the left. The photograph was taken by George R. King in the summer of 1916. Elms were once a very common tree in America, gracing streets and yards, but most were killed by Dutch elm disease, which was introduced in the early 20th century.

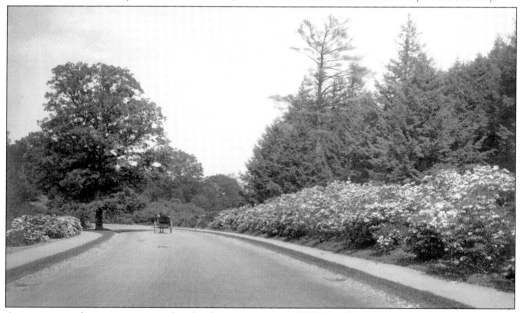

A carriage makes its way past a bank of mountain laurel (*Kalmia latifolia*) at the base of Hemlock Hill. These showy shrubs received their Latin binomial from Carl Linnaeus (1707–1778), the Swedish botanist. Linnaeus, considered the father of modern binomial nomenclature, published his *Systema Natura* in 1735, in which he regularized the use of consistent genera and species for naming plants.

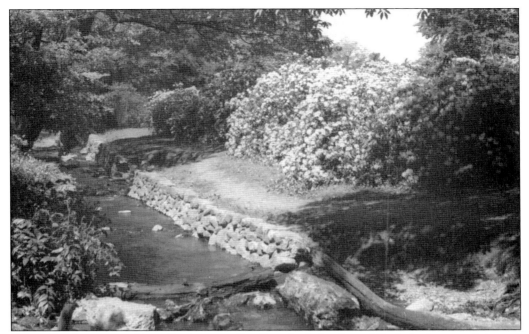

Bussey Brook is pictured here flowing past Carolina rhododendrons (*Rhododendron carolinianum*) on May 26, 1954. Erosion of the banks of Bussey Brook has been an ongoing challenge over the years. This photograph features a stone embankment that was installed to help alleviate this problem.

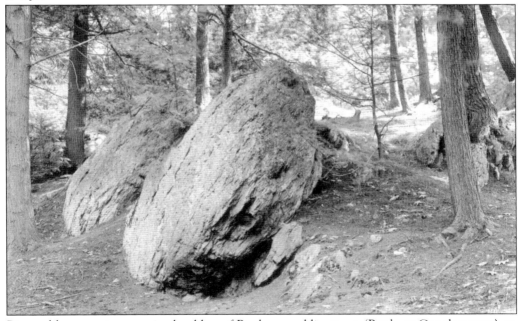

Pictured here are two massive boulders of Roxbury puddingstone (Roxbury Conglomerate) on Hemlock Hill. This type of rock, which underlays the local area, can be seen in outcrops throughout the landscape. These boulders were deposited on the Hemlock Hill drumlin as the ice retreated at the end of the last ice age. They were photographed by Thomas E. Marr on March 30, 1903.

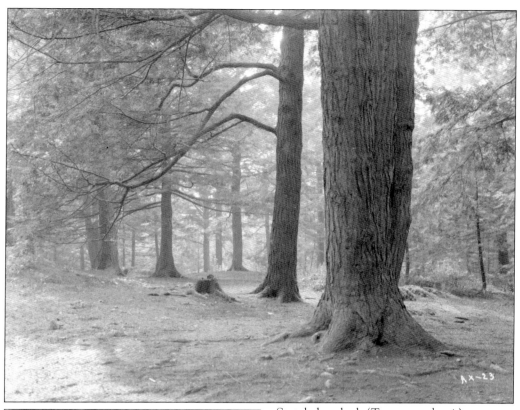

Stately hemlock (*Tsuga canadensis*) trunks stand on Hemlock Hill in this 1916 photograph by George R. King. King, who was based in Boston, was a noted photographer of American parks in the early 20th century and worked for a number of commercial photographic companies. He was born in Nova Scotia in 1866 and died in California in 1951.

A path wends its way through the hemlocks on the side of Hemlock Hill in a 1927 photograph by George W. Root. Although this might seem like a scene of virgin forest, trees were logged in the 18th century to feed a local sawmill. The steep and rocky terrain prevented former owner Benjamin Bussey from using the land for pasture.

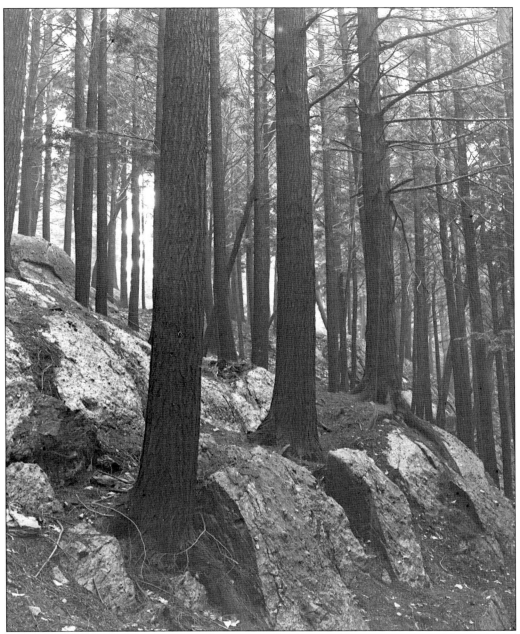

Hemlocks (*Tsuga canadensis*) tenaciously grow over Roxbury puddingstone rocks on Hemlock Hill in this lantern slide by Alfred Rehder from January 1902. This image captures the hemlocks in a moment in time prior to the destructive hurricane of 1938 that knocked down so many trees at the Arnold Arboretum and elsewhere in the northeastern United States. Newspapers at the time estimated that 100 million trees were lost in Massachusetts alone. Horticulturist Donald Wyman concurred with that number, and in spite of the loss of over 1,400 trees on the grounds, he felt that the arboretum was less badly hit than it might have been, with its losses primarily being to native species as opposed to unique Asian plants. Clean-up took all winter and was aided by the purchase of a portable power saw, the first in Arnold Arboretum history.

A grass path passes the young conifer collection in a May 1903 photograph by Thomas E. Marr. The early cut-grass paths in the arboretum were mown not by motorized mowing machines, but by laborers working by hand with scythes. With a sharp scythe, a skilled mower can cut grass almost as closely as with a machine and access steep or uneven areas easily.

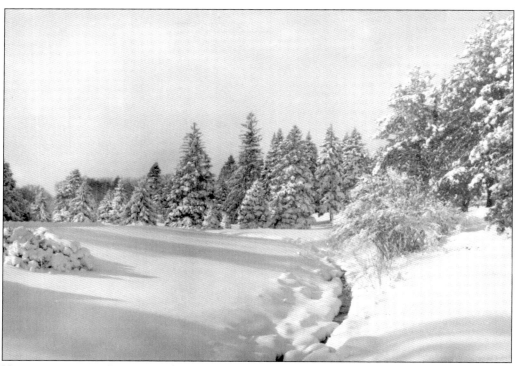

Heavy snow covers Bussey Brook and the conifer collection in this December 1948 photograph by Donald Wyman. In a recap of the winter of 1948–1949 in *Arnoldia*, Wyman says that storms predicted for February and March never materialized, and despite what this image might imply, the winter was a mild one.

George R. King captured this view along Centre Street on the west side of the arboretum in the summer of 1917. The heavy puddingstone blocks making up the perimeter wall are nearly enveloped in verdant vegetation, including several grapevines. At this time, Centre Street was a two-lane gravel road. It was not until 1931 that it was widened to its present four-lane configuration.

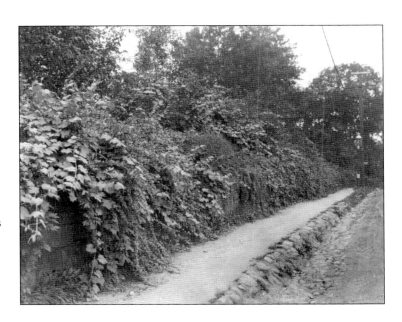

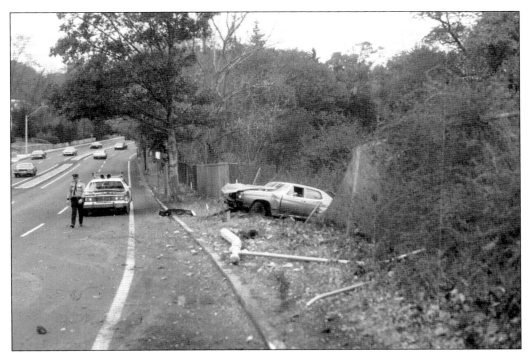

Improvements to Centre Street and better automobiles meant much faster driving on this well-traveled stretch of road. Accidents were bound to happen, like this crash in November 1974, which occurred near the gate to the Dana Greenhouses and took down a lamppost and section of perimeter fence.

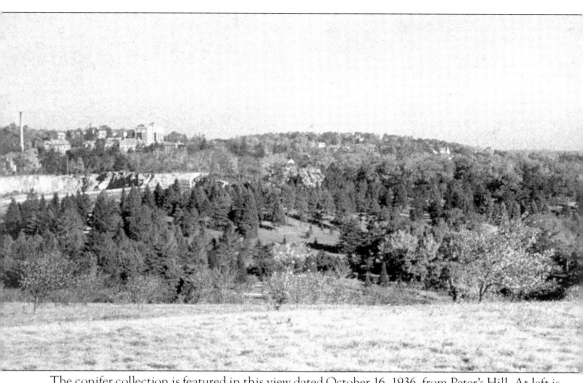

The conifer collection is featured in this view dated October 16, 1936, from Peter's Hill. At left is Centre Street, and Faulkner Hospital can be seen beyond. Allendale Road is just hidden by trees at the center of the image. In the 18th century, the Peacock Tavern stood on its south corner and was noted for its extensive grounds and the mineral springs nearby. The property was bought in 1794 by Samuel Adams, who lived there while he was governor of Massachusetts. Across Centre Street, set into the puddingstone wall, is the Paul Dudley stone, marking six miles to Boston. Prior to the founding of the arboretum in 1872, this portion of the property along Centre Street contained several homesteads. One of these houses was occupied in the 1850s by Simeon Giles (1780–1858), a free African American man who was a farmer and woodcutter.

Muriel Primrose Wilson (1906–1976) stands beside a specimen of redbud crabapple (*Malus* × *zumi* var. calocarpa) in a photograph dated May 31, 1926, taken by her father, Ernest Wilson. The red buds of this showy crabapple open to frothy white blossoms. In the fall, the tree bears small red fruits.

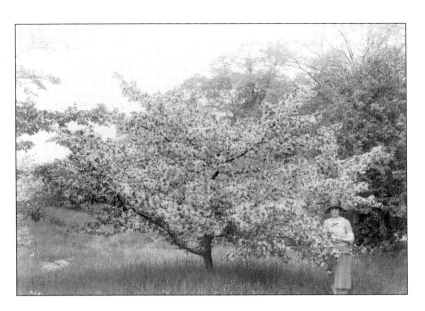

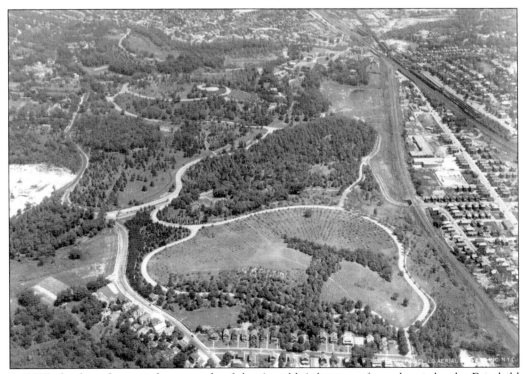

In 1927, the first photograph was made of the Arnold Arboretum from the air by the Fairchild Aerial Surveys. Here, the landscape is captured from south to north, with Peter's Hill in the foreground. The neat rows of hawthorns (*Crateagus*) can be clearly seen. They had been specially collected and studied by Charles Sargent.

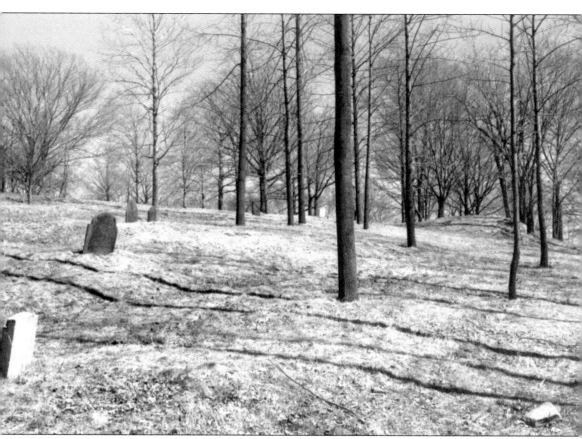

In the early Colonial period, residents of the Jamaica end of Roxbury had to travel three or more miles to the meetinghouse in the center of town to attend church or civic functions. By the end of the 17th century, they had had enough and in 1706 petitioned to have a second parish created in their part of town. The general court refused, so parishioners took matters into their own hands and built a meetinghouse on donated land on Walter Street. They laid out a graveyard adjacent to it, and burials began soon after. Later in the 18th century, the church was dismantled and moved farther down Centre Street into what is now West Roxbury. The cemetery remained, and burials continued into the 19th century. A survey in 1850s listed 49 headstones, but far fewer remain today. The oldest is that of Anna Bridge, dated to 1722. Heman Howard photographed the burying ground on April 11, 1960, to illustrate an article in the arboretum's quarterly publication, *Arnoldia*.

Four

Arnold Arboretum Activities

The Arnold Arboretum is more than a museum of woody plants. It is, and always has been, a living organization full of activity—from grounds maintenance to pruning classes and botanical society meetings—making it a vibrant institution. The staff has provided formal and informal learning experiences to visitors from the early days of the arboretum, and scholars have long sought out the living and nonliving collections for their research. The hardworking horticultural crew keeps the grounds looking beautiful and, even more importantly, cares for the health of the trees, shrubs, and vines in the landscape. Dedicated volunteers lead tours for visitors and guide school students in their field studies. Guests can attend thought-provoking lectures at the Hunnewell and Weld Hill Research Buildings or on the grounds with distinguished scholars. Most of all, everyone can enjoy the tranquility of nature year-round in the midst of a busy city.

Public education has long been a cornerstone activity at the Arnold Arboretum. John Jack, seen here leading field studies in the hickory collection around 1900, was a leading force from the earliest days of the institution. He conducted courses in dendrology, the study of trees, using the arboretum's living collections as his classroom. Courses were geared toward the layperson, and his amicable disposition made them popular. According to the annual report for 1890–1891, he "gave twice a week during the months of May and June, instruction . . . which treated of the plants, in their botanical, economic, and ornamental aspects, were practical and interesting." As director of the Arnold Arboretum, Charles Sargent was the Arnold Professor of Botany and was tasked to teach the knowledge of trees at Harvard College. He delegated this function, with the approval of the trustees, to Jack, who became a lecturer in arboriculture in 1890.

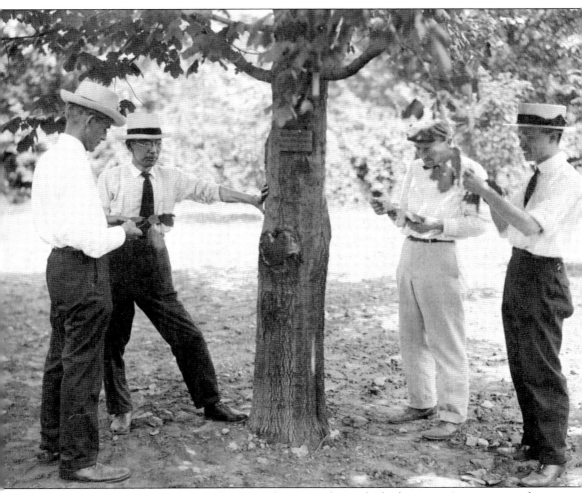

John Jack took an active interest in educating Chinese students who had come to America to study botany. While the arboretum did not confer degrees, students could matriculate at the Bussey Institution and then study with him. An early student was Woon-Young Chun (Chen Huanyong, 1890–1971), who came to study with Jack in 1915. Students like Chun came halfway around the world to study the tree flora of their native country because of the convenience of having an extensive living collection and complete herbarium all in one place. In a 1917 interview, Chun remarked, "It would take me a lifetime of travel to study what I can find out here about Chinese trees in a few years." One of Jack's most notable students was H.H. Hu (Hu Xainsu, 1894–1968), who first identified and named living examples of *Metasequoia glyptostroboides*, the dawn redwood, a tree thought to be extinct but found growing in Hubei Province, China, in the 1940s. Pictured here are John Jack (left) with two unidentified students and Woon-Young Chun (right) in 1917 in a photograph by A.A. Greenlaw.

Donald Wyman (center in the dark grey suit) is pictured here teaching a field-study class in the lilac collection in the spring of 1954. Wyman continued the tradition started by John Jack of teaching classes out in the landscape.

In the cooler months, classes and lectures move indoors. Here is a photograph taken in November 1954, of Richard Alden Howard (1917–2003) leading a class on Caribbean fruits. Besides being the fifth director of the Arnold Arboretum, Howard was an expert on tropical botany and author of Flora of the Lesser Antilles.

Classes on practical subjects in horticulture have long been popular with visitors to the arboretum. Here a class is listening attentively as the teacher (nearly hidden behind the shrub) demonstrates correct pruning techniques in the spring of 1957.

Arboretum visitor education is sometimes hands-on, as evidenced in this photograph taken by Heman Howard in November 1954 of a class on grafting. This class, which was one session of a multipart course on plant propagation, included practical as well as classroom instruction. It was initiated as part of an education program devised by Carroll Wood (1921–2009), which included basic botany and Caribbean botany.

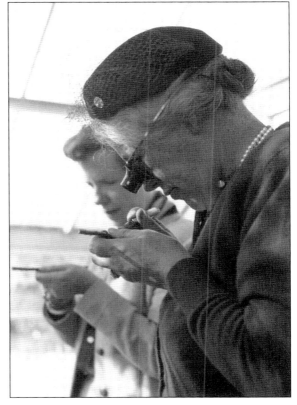

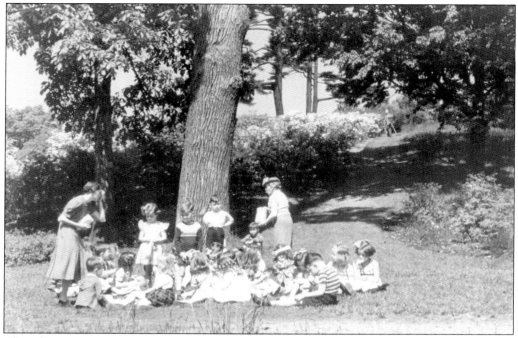

The arboretum has long been a place for children from the city of Boston to experience nature firsthand. Pictured here in the late 1930s with their teachers is a group of children on the slope of Bussey Hill sitting down to eat their lunches.

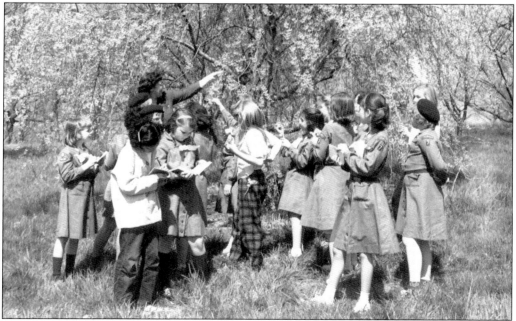

Children's education has become increasingly more important to the mission of the arboretum. Here, a troop of Girl Scouts examines a Higan cherry tree (*Prunus subhirtella*) on April 26, 1960, with their guide. Today, the arboretum brings science education programs to Boston-area public schools and welcomes classes to the grounds for field-study experiences.

Students from the local agricultural high school are seen judging potted flowering plants in this photograph from March 16, 1966. The arboretum actively encourages youth education and today hosts students from the Norfolk Agricultural High School for a five-week spring internship during which they work alongside the horticultural staff.

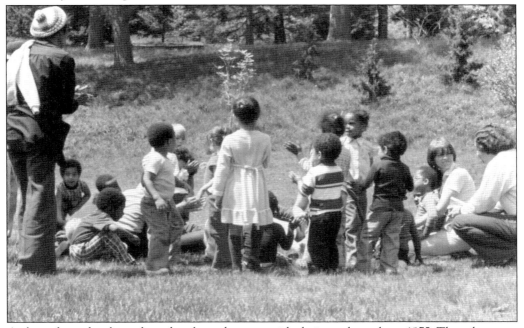

A class of preschoolers takes a break on the grass with their teachers about 1975. The arboretum provides field-study experiences for local Head Start classes, which can be the spark to kindle a lifelong love of the outdoors.

The arboretum's association with the Massachusetts Horticultural Society extends back to the days of Charles Sargent. On May 23, 1959, the arboretum hosted the organization's annual field trip, which featured bus tours of the grounds for its members.

Ladies from a Boston-area garden club are pictured here listening to a lecture by Donald Wyman on May 22, 1957. The arboretum has had a long association with local garden clubs and provided a venue for outings and meetings for many years. The Arnold Arboretum Archives is the repository of the records of the Garden Club Federation of Massachusetts.

Carroll Wood, associate curator of the Arnold Arboretum, can be seen in the center of this photograph holding a cut section of a tree trunk. He is teaching a basic botany course in November 1955.

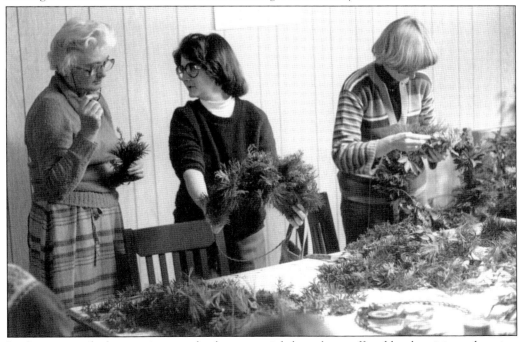

In the past, craft classes using woody plant materials have been offered by the visitor education department. Here, a student (left) and the instructor (center) discuss a project during a December 1978 Christmas wreath–making workshop.

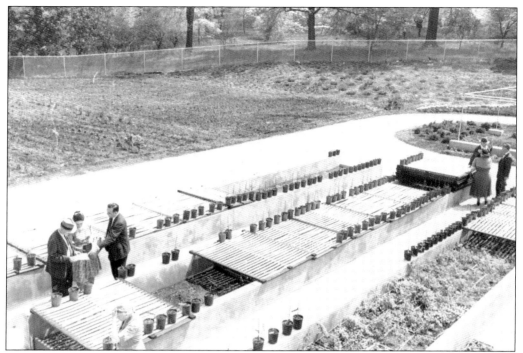

After the Dana Greenhouses were completed in the spring of 1962, an open house was held for Friends of the Arnold Arboretum on Saturday, May 19. Pictured here are guests examining the new planting beds and a view of the nursery area beyond.

Arboretum Friends' activities have also included special exhibitions and openings. Guests are pictured here deep in conversation in the lecture hall of the Hunnewell Building in spring 1971 at a display of posters from foreign countries concerning conservation, wildflower protection, and ecology.

Arboretum volunteer Elinor Trowbridge (center in the light-colored jacket) and two other women plant spring flowering bulbs along the tree line by the Hunnewell Building lawn in the fall of 1970. The bulbs were purchased with a generous donation of the Friends of the Arnold Arboretum.

In February 1963, the Arnold Arboretum hosted the annual meeting of the American Society for Horticultural Science. Here, members are relaxing and enjoying some refreshments in the headhouse of the Dana Greenhouses.

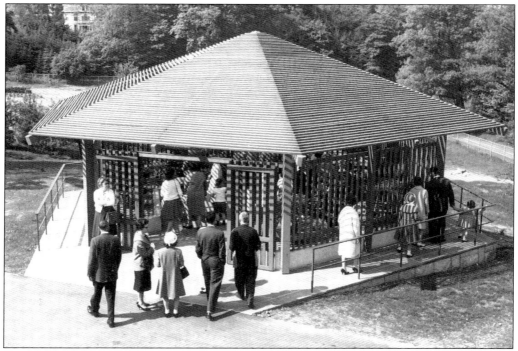

On Sunday, May 20, 1962, the arboretum opened its gates wide to welcome visitors for Lilac Sunday. Here, men and women in their Sunday best examine the newly completed lath house, which shelters the Larz Anderson Collection of Japanese Dwarfed Trees. These venerable bonsai, some of which are over 300 years old, were given to the arboretum by Isabel Anderson in 1937.

Another photograph from Lilac Sunday 1962 captures visitors strolling in the sunshine on Meadow Road. The excellent weather drew large crowds, which tied up traffic on the roads around the arboretum. An estimated 25,000 guests enjoyed the spring blooms that day, a return to pre–World War II attendance levels.

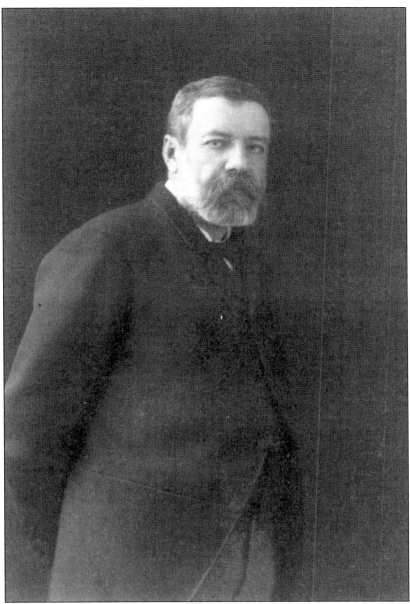

In 1892, Charles Sargent journeyed to Japan and spent over two months botanizing in the forests, networking with colleagues, and visiting points of botanical interest across the country. He called upon Prof. Kingo Miyabe at the Sapporo Agricultural College, the first of many visits Dr. Miyabe would receive from arboretum plant explorers. Unfortunately, Sargent did not photograph his trip, but he did bring back 1,225 dried botanical specimens and seeds of approximately 200 different species, many of them completely new. Two of the showiest bear his name, the Sargent crabapple (*Malus sargentii* Rehder) and the Sargent cherry (*Prunus sargentii* Rehder). In 1894, Sargent published *The Forest Flora of Japan*, a compilation of articles that had originally appeared in *Garden and Forest*, detailing notable woody plant families of Japan. The articles are enriched with botanical illustrations by Charles Faxon, who had provided the drawings for Sargent's *Silva of North America*. This photograph of Sargent was taken at about the time he visited Japan in 1892.

As well as being a noted educator, John Jack was already an experienced plant explorer when he embarked on his trip to Asia in 1905, becoming the second arboretum staff member after Charles Sargent to visit Asia. He focused his travels on Japan and Korea but was able to visit China as well. Although Sargent's 1904–1905 annual report states that "Mr. J.G. Jack has started on a journey to the East to obtain material for the Arboretum in Japan, Korea, and northern China," his journey was self-financed. In addition to collecting seeds and herbarium specimens, Jack photographed trees, forestry practices, and landscape views, including some as lantern slides, a format especially useful for his teaching. Covering some of the ground that Ernest Wilson later explored, Jack photographed the forest preserves and activities of the timber industry in Japan, as well as the forests of Taiwan and Korea. He is seen here in a photograph taken in 1904 just prior to his trip.

Arboretum plant explorer Ernest Wilson was born in England and apprenticed in the nursery trade. He was a gardener at the Birmingham Botanical Gardens and joined the staff at the Royal Botanic Gardens, Kew in 1897. He collected plants in China for Veitch nurseries from 1899 to 1902 and then from 1903 to 1906. For three years beginning in 1907, Wilson explored Hubei and Sichuan Provinces for the arboretum. His second arboretum expedition, which began in 1910, was cut short when he was caught in a landslide, crushing his leg. In 1914, Wilson explored Japan, focusing his attention on conifers, azaleas, and Japanese cherries. Beginning in 1917, he undertook an exploration of Korea, Japan, and Formosa (Taiwan), returning in 1919 with seeds, living plants, and herbarium specimens. His last expedition, a tour of the gardens of the world took place from 1920 to 1922. Wilson was a popular lecturer on the topics of his travels and horticulture. In 1930, he and his wife, Ellen, were killed in an automobile accident. He is pictured here on the front steps of the Hunnewell Building.

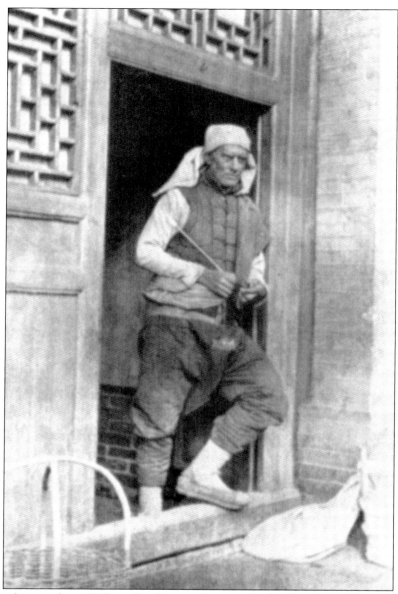

Arboretum plant explorer William Purdom was born in England and trained as a nurseryman before being hired by the Royal Botanic Gardens, Kew. In 1909, Charles Sargent was intent on having as many men as possible collecting China's flora and keen to dispatch a collector to the northeastern provinces. Purdom's goal was to collect plants from areas with weather more severe than that of New England. Unfortunately, while his expedition did not measure up to the exploits of Wilson in numbers of plant introductions, he was able to take a substantial number of anthropological and ethnographical photographs of the people he encountered, documenting their life, dress, and hairstyles. Purdom also is noted for his later exploration in China with Reginald Farrer (1880–1920). At the conclusion of their expedition in 1916, Purdom remained in China to become a division chief within the Chinese Forest Service. Following a minor operation, he died at the French hospital in Beijing on November 7, 1921. In this photograph, he is in the disguise of a Chinese laborer.

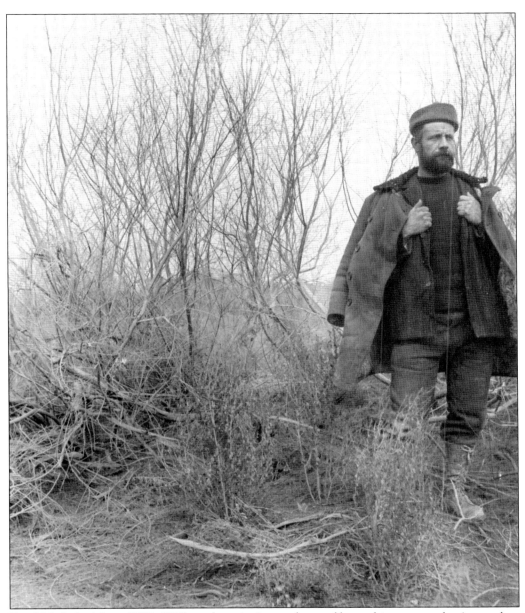

Frank Nicholas Meyer (1875–1918) was born in Amsterdam and began his career at the Amsterdam Botanical Garden, where he worked his way up to the position of head gardener in charge of the experimental garden. He arrived in America in 1901 and obtained work with the US Department of Agriculture. After a year with the agency, he went to Mexico to collect plants. On his return in 1904, David Fairchild (1869–1954) of the Foreign Plant Introduction Section of the USDA hired Meyer to make a collecting trip to China. When Meyer sailed for China in 1905, he began a 13-year odyssey that led to the introduction of more than 2,000 species of plants, many of them of great economic value. In an arrangement between Charles Sargent and Fairchild, Meyer sent the arboretum trees and shrubs of ornamental value. Meyer died in China in 1918 after a fall from a boat. Meyer is pictured here in a thicket of tamarisk (*Tamarix* L.) in Tumchuk, Xinjiang Uygur Zizhiqu, China, on February 12, 1911.

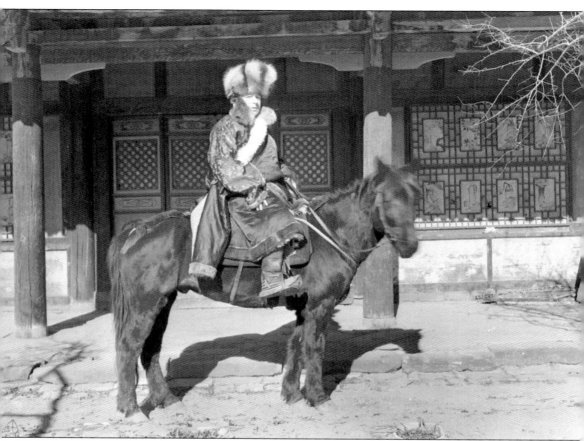

Arboretum plant explorer Joseph Rock was a botanist, anthropologist, explorer, linguist, and author who emigrated from Austria in 1905. From 1907 to 1920, he lived in Hawaii, where he became a specialist on Hawaiian flora. From 1920 until 1949, Rock explored, photographed, and collected plants in Asia for the arboretum, the USDA, the National Geographic Society, and others. In 1924, Charles Sargent hired Rock to explore China and Tibet along the Yellow River and in the Amne Machin and Richtofen mountain ranges. He also collected along the Yangtze River, the Gansu-Sichuan border, and around Koko Nor Lake in Tibet. Rock collected 20,000 herbarium specimens and many packages of propagative material. Although he found few new species, he collected hardier forms of species that had already been collected by others. From 1945 to 1950, he was a fellow at the Harvard Yenching Institute, where he published his linguistic research. Later, he returned to Hawaii and became a professor of Oriental studies. He died there in 1962. He is seen here in Tibetan dress on a pony.

Arboretum visiting committee member Susan McKelvey was born into the highest circles of New York society. Educated at Bryn Mawr, she soon married; a decade later, her marriage fell apart, and in 1919, she left New York for Boston. She approached Charles Sargent about studying landscape design with him, and he offered her a job washing pots in the greenhouse. She persevered, and Sargent, impressed by her dedication, encouraged her to study the plants of the arboretum. She turned her attentions to the genus *Syringa*—the lilacs—and some 10 years later published a nearly 600-page study on the subject. About this time, she began winter trips to the American Southwest to botanize and collect material for a work on yuccas, which was published in two volumes from 1938 to 1947. Her final publication was a monumental study of botanical expeditions in the western United States. Here, she pauses with her chauffeur Oscar E. Hamilton (1900–1969) as they prepared to embark an expedition to the Southwest about 1930.

During the early years of the arboretum, the open fields where the Leventritt Shrub and Vine Garden is sited today was used for raising hay. In this 1931 photograph by Ernest Palmer are the massive stacks, easily 15 feet high, with men loading some of the crop onto a wagon.

Thomas Curry is pictured here contour plowing on Peter's Hill in August 1951. In the late 1940s and into the early 1950s, Charles Sargent's hawthorn collection was removed from the north side of Peter's Hill and the land plowed and cultivated to renew its vigor. It was then planted with crabapples and mountain ashes as well as some hawthorns. Curry would later become assistant superintendent of the arboretum.

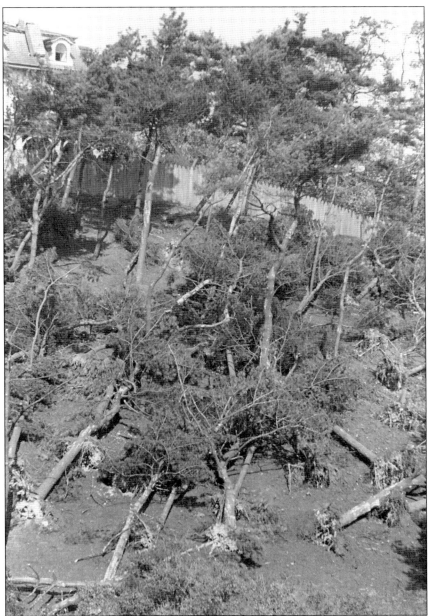

On September 21, 1938, a Category 3 hurricane struck the northeastern United States. It caused the deaths of over 600 people and destroyed thousands of homes. New England was hard-hit, and the Arnold Arboretum was not spared. The storm inundated the ground with four days of heavy rain, causing the soil to become soft and spongy. The high winds that followed toppled hundreds of trees in the arboretum landscape. Donald Wyman estimated that portions of the grounds received winds in excess of 100 miles per hour. Elmer Merrill was on the ground during the height of the tempest and stated that the worst damage occurred between 5:30 p.m. and 6:30 p.m. that evening. Here is a scene of massive destruction in the area occupied today by the Leventritt Shrub and Vine Garden. In the background, the main house of the Adams Nervine Asylum has had a chimney blown over.

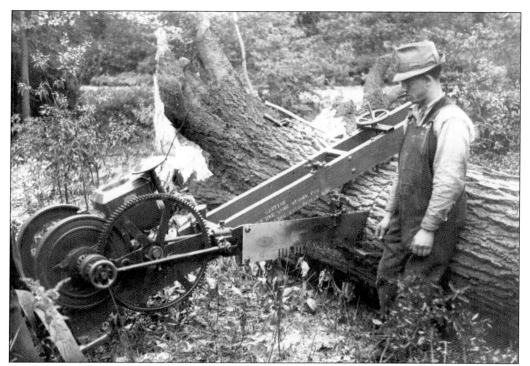

A member of the arboretum horticultural crew uses a mechanical saw, the first one owned by the institution, to cut up one of the nearly 1,500 trees brought down during the 1938 hurricane. Previous to the purchase of this saw, all tree removal had to be done with axes or a two-man crosscut saw. Donald Wyman captured this photograph in fall 1938.

After hurricanes and other extraordinary storms, trees are often blown over or severely tipped. Sometimes they can be reset in the ground, as seen here in a photograph taken after Hurricane Edna in September 1954. This hurricane was the second one to strike that summer, preceded on August 31 by Hurricane Carol.

The destruction of the two hurricanes in 1954 prompted the purchase of the arboretum's first brush chipper, seen here in action in September 1954. Above, Thomas O'Loughlin is feeding plant material into the chute. The chippings were applied as mulch to some plantings on the grounds, but spent hops from Jamaica Plain's breweries remained the preferred material for mulching.

Jackson Dawson is pictured here in 1904 in an early horseless carriage heaped with freshly cut plant material. Dawson was renowned for his ability to coax life into "a twig found in the pocket of a shooting jacket weeks after this had been laid aside."

Ladies in their spring hats are walking amongst the lilacs in full bloom on Lilac Sunday in a May 17, 1936, photograph by Donald Wyman. This annual event always attracts crowds of visitors, and the arboretum horticultural staff works hard beforehand to ensure the grounds look their best.

This is another scene from Lilac Sunday 1936 taken by Donald Wyman. Here, crowds are making their way up into the collections for a look at the flowers. It was cool that day, as evidenced by the number of visitors in overcoats. Today, the weather can vary from cold to hot, but one thing is for sure, the lilac collection blooms earlier today than it did years ago.

Centre Street was busy on Lilac Sunday 1936. This image shows the road, which had been improved five years previously. The original proposal called for widening the parkway to a width of 100 feet and planting the center median with trees. The arboretum objected because it would have caused the loss of a number of trees. A compromise saved the trees and narrowed the roadway to 80 feet.

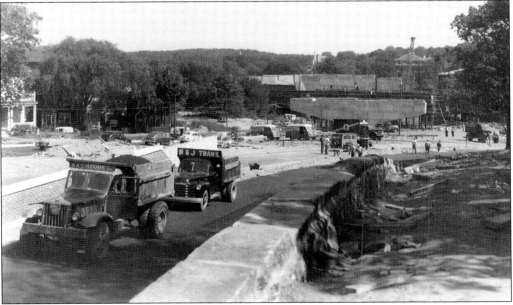

Traffic is carried along the east side of the arboretum on the Arborway. Between 1952 and 1953, the Casey Overpass was constructed to carry automobile traffic over the elevated train line at Forest Hills Station and on to the Franklin Park area. In 2015, the overpass was demolished in favor of an at-grade intersection. Here is a photograph from September 1952 of the newly constructed supporting piers for the elevated roadway.

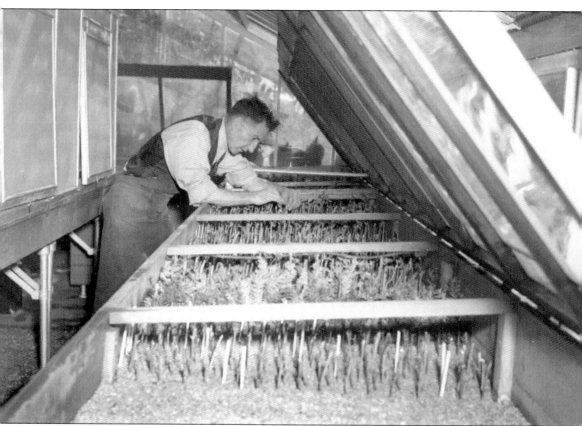

William Henry Judd (1888–1946) was born in England and apprenticed as a gardener. He received the foundation of his propagation training at the Royal Botanic Gardens, Kew and in 1913 came to America to become Jackson Dawson's assistant in the greenhouse. When Dawson died in 1916, Judd was appointed arboretum propagator. He was a gifted plantsman who was also a meticulous record keeper, a skill honed during his time at Kew, and a voluminous correspondent, networking with other botanists, taxonomists, and horticulturists worldwide. His green fingers raised the seeds brought back by Ernest Wilson on his 1917–1919 and 1920–1922 expeditions, and their horticultural success can be traced to Judd's excellence at propagation. In 1931, he was a recipient of the Jackson Dawson Gold Medal from the Massachusetts Horticultural Society and in 1945 of the Veitch Memorial Gold Medal from the Royal Horticultural Society, London. Judd is pictured here in his greenhouse about 1925.

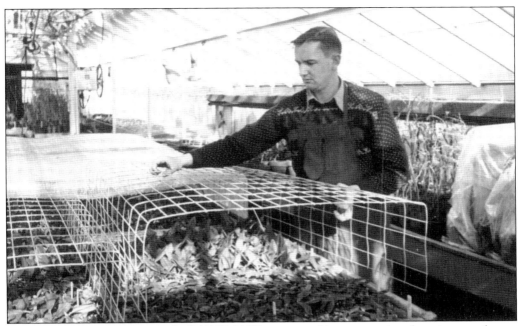

Plant propagator Roger Coggeshall (1927–2013) is pictured here removing the wire cage from a propagating case in the arboretum greenhouses on the Bussey Institution grounds in 1955. This greenhouse was one of several built on the Bussey grounds by the Lord and Burnham Company for the arboretum in 1928.

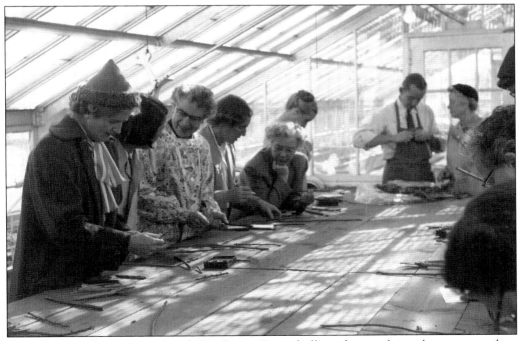

As well as his plant-propagation duties, Roger Coggeshall taught a multi-week course on plant propagation. In a November 1954 photograph by Heman Howard, the ladies of the Wednesday morning class are shown in the greenhouse practice their grafting technique.

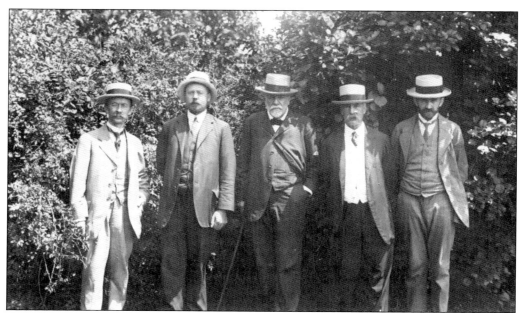

Five of the leading botanists of the Arnold Arboretum gather in the summer of 1916. From left to right are Alfred Rehder, Ernest Wilson, Charles Sargent, Charles Faxon, and Camillo Schneider (1876–1951). Austrian-born Schneider was a botanist, writer, and plant collector. He came to the arboretum in 1915 on his way back from a plant-collecting expedition in China and worked on the staff until 1919.

Some of the arboretum staff are pictured here on September 1, 1933, at a party for Alfred Rehder's 70th birthday. From left to right are (first row) Oakes Ames, Alfred Rehder, Anneliese Rehder, Ethelyn Tucker, Sylvia Rehder, Katherine Kelly, Hariklea Yeranian, Eleanor Stuhlman, Margaret Judge, Heman Howard, Caroline Allen, Ethel Anderson, Victor Schmitt, Edmund Wilberding, and Alfred Fordham; (second row) Ernest Palmer, Harald Rehder, John Jack, J. Morse, and Clarence Kobuski.

Men from the arboretum grounds and administrative staff gather for some holiday cheer in December 1954. Pictured here are, from left to right, (first row) Heman Howard, John Straniski, Patrick Connors, Andrew Tomasonis, Thomas Curry, Archibald Williamson, and Gallo; (second row) Donald Wyman, Harry Hill, Alfred Fordham, Grant Bethel, Everrett Vandersnoek, Karl Sax, Artur Noreitus, Roger Coggeshall, and Patrick O'Connor; (third row) Timothy McGlaughlin, Robert Williams, and Richard Howard.

Women from the arboretum staff are pictured here in December 1965. Pictured are, from left to right (first row) Judy Endicott, Anne Sholes, and Stephanie Sutton; (second row) Rosemary Walsh, Eileen Twohig, Alice Purdue, Judy Appenzeller, Claire Schloemer, Elsie Howard, Mildred Pelkus, and Phoebe Chapman.

The Arnold Arboretum staff group portrait from 1970 includes, from left to right, (first row) Dr. Lily Perry, Stephanie Sutton, Jeanne Caldwell, Nancy Page, Emilie McCarthy, Victoria Bell, S. Kaye, M.T. Hallaran, Elna Grinsbergs, Pamela Bruns, Rosemary Walsh, Nancy Dunkly, Dulcie Powell, Bernice Schubert, and Helen Roca-Garcia; (second row) Richard Howard, Alfred Fordham, Harry Hill, Ralph Benotti, Artur Ginters, Charles Mackey, Syed Kazmi, A. Linn Bogle, Gordon DeWolf, Heman Howard, Mildred Pelkus, Virginia Savage, Winnifred Hebb, Robert Hebb, Lorin

Nevling, William Grime, Willie Casterlow, Vincent Antonovich, Ernest Abolins, Peter Ward, Angus McNiel, and Walter Polesky; (third row) Arthur Norietis, George Pride, Thomas Kinahan, Thomas Elias, Carroll Wood, Clarence Parker, Daniel Reuben, Joachim Hourihan, Michael Canoso, Scott Vonnegut, Paul Sorensen, Thomas Hartley, Norton Miller, Carl Joplin, William Schwabe, Robert Williams, Maurice Sheehan, Michael Gormley, Henry Goodell, Timothy O'Leary, and Domingo Rivera.

Pictured here is a display of arboretum equipment in front of the Hunnewell Building in the late 1940s. Starting in the 1930s, machinery began to be employed as a labor-saving expedient, which increased during World War II when many of the grounds staff were drafted for military service.

Arboretum student worker John Taylor (1925–2005), from Christchurch, New Zealand, is seen here operating a rotary-disk mower on July 7, 1949, in a photograph by Heman Howard. Taylor studied that year with arboretum director Karl Sax and spent the next at the New York Botanical Garden before returning to New Zealand to become assistant curator of the Christchurch Botanic Garden.

Two members of the horticultural staff are seen at work removing suckering shoots from a lilac plant in May 1957 in preparation for Lilac Sunday. Lilacs can be prone to producing suckers, which are sprouts sent up directly from the roots.

Vincent Antonovich is pictured in this photograph by Heman Howard operating a large mower during August 1965. In the early days of the arboretum, when horsepower was still the norm, the grass was allowed to grow tall, and local farmers cut and carried away the hay.

Horticultural staff members steady a limber pine (*Pinus flexilis*), which has been balled and burlapped in preparation for being moved from Peter's Hill to the conifer collection in 1929. Arboretum superintendent Victor Schmitt can be seen seated in the front with his arms crossed. The names of the other men in the photograph are unknown.

This is how not to prune a tree. Herbert Cole is seen here cutting a large oak branch with a McCulloch 18-inch chain saw on August 26, 1952. Today, the arboretum's licensed certified arborists follow strict national safety standards, which include the use of helmets, eye protection, proper clothing, and safety rigging.

From the mid-1960s through the 1970s, vandalism began to occur more frequently on the grounds. Here, arboretum staff member Vincent Antonovich is examining the senseless destruction of a rare *Abies faxoniana*, which was cut down on February 15, 1966. The same vandals had cut down nearly two dozen arboretum trees over the previous year.

Here is another photograph from February 15, 1966, of more vandalism, which had occurred on the previous day's destruction spree. Vincent Antonovich (left) and another employee examine a smashed bench and trash can on Peter's Hill. The perpetrators left hand-scrawled calling cards carrying the name of their gang, "Shot Bros."

During this period, vandals were also known to drive cars to the top of Peter's Hill, pushing them down so they would careen into the trees and shrubs, as seen in this photograph from the spring of 1966.

Horticultural staff member Maurice Sheehan is pictured here spraying a brush fire on the grounds about 1974. Fires in the arboretum, whether naturally occurring or deliberately set, can cause significant damage to the collections. Today, smoking is prohibited on the grounds, as it is in all Boston city parks, squares, cemeteries, and other locations run by the parks and recreation department.

The challenges of littering and vandalism throughout the 1970s prompted arboretum director Peter Ashton (seated in the center in the dark shirt and light suit) to look for a solution. Partnering with other concerned organizations, the arboretum collaborated to create the Boston Park Ranger Program. It was based on a similar program in New York City, and on April 24, 1982, some of those rangers visited the arboretum to discuss their successes.

A mounted park ranger and two other rangers are joined by director Peter Ashton and state representative Maura Hennigan on May 17, 1983. During its first years, the program operated seasonally. Today, it provides year-round security and safety, visitor services, resource management, and interpretive programming not only in the nine Emerald Necklace parks, but also in Boston's historic burying grounds, neighborhood parks, and playgrounds.

Arboretum volunteers Lou Segel (left), Al Thompson (center), and Cora Warren (right) are pictured here collecting leaves and other material from a tree about 1975. The material was then flattened in wooden lath plant presses, where it was allowed to dry. After drying, it was mounted on acid-free herbarium sheets and added to the arboretum's herbarium of cultivated plant specimens.

In this group photograph of arboretum volunteers from 1978 are, from left to right, (first row) Cora Warren, Doty Loomis, Marie Dempsey, Loretta Wilson, Sheila Maguillion, Elinore Trowbridge, and Sylvia Grey; (second row) Al Thompson, Gertrude Cronk, Barbara O'Connor, Janet Thompson, Richard Dwight, June Hutchinson, Bob Segel, Nan Whittier, Leslie Oliver, and Lou Segel.

Longtime arboretum volunteers Flora and Al Bussewitz (standing left) and arboretum managing horticulturist Gary Koller (seated in the dark jacket) speak with arboretum library benefactor Mary Binney "Polly" Wakefield (right) at a reception about 1978.

Visitors are pictured here examining plants at the arboretum members' plant giveaway in 1978. Mrs. Frederick Goode is standing at the center of the photograph in the white coat.

BIBLIOGRAPHY

Hay, Ida. *Science in the Pleasure Ground.* Boston, MA: Northeastern University Press, 1995.

Sargent, Charles Sprague. *The Silva of North America: A Description of the Trees Which Grow Naturally in North America Exclusive of Mexico.* Boston, MA: Houghton Mifflin and Company, 1891–1902.

———. *Garden and Forest; A Journal of Horticulture, Landscape Art and Forestry.* New York: The Garden and Forest Publishing Co., 1888–1897.

Spongberg, Stephen A. *A Reunion of Trees.* Cambridge, MA: Harvard University Press, 1990.

INDEX

Ames, Oakes, 10, 51, 52, 114
Arborway Gate, 37, 38, 45, 47
Arnold, James, 7, 22–24
Bonsai, 68, 69, 98
Bussey, Benjamin, 7, 11, 17, 18, 21, 23, 30, 36, 63, 80
Bussey Brook, 14, 16, 31, 34, 37, 76, 77, 79, 82
Bussey Hill, 14, 27, 29, 30, 32, 33, 37, 54, 55, 60, 70, 72, 73, 75, 92
Bussey Hill Road, 33, 58, 60, 61, 70, 74
Bussey Institution, 8, 24, 28, 36, 51, 52, 55, 56, 58, 66, 89, 113
Centre Street, 66, 70, 83, 84, 111
Coggeshall, Roger, 113, 115
Conifer collection, 37, 77, 82, 84, 120
Dana Greenhouses, 9, 66–69, 97
Dawson, Jackson, 9, 32, 58, 63, 64, 109, 112
Emerson, George, 24, 31
Farrand, Beatrix, 9, 49, 51
Faxon, Charles, 8, 9, 28, 44, 59, 99, 114
Fordham, Alfred, 12, 57, 114–116
Hemlock Hill, 12, 14, 27, 30, 31, 34, 76, 78–81
Hemlock Hill Road, 31, 37
Hunnewell Building, 13, 28, 34, 37–41, 43, 45–48, 71, 96, 97, 101, 118
Jack, John, 8, 33, 36, 46, 88–90, 100, 114
Lilac collection, 33, 37, 56, 58, 61, 62, 90, 110
McKelvey, Susan, 9, 105
Meadow Road, 33, 34, 49, 50, 54, 65, 98
North Meadow, 30, 37, 45, 47, 48
Oak collection, 14, 15, 27, 74, 75
Olmsted, Frederick Law, 7, 9, 23, 26, 27, 30
Peter's Hill, 29, 37, 84, 85, 106, 120–122
Purdom, William, 8, 102
Rehder, Alfred, 39, 42, 59, 77, 81, 114
Rock, Joseph, 9, 51, 104
Sargent, Charles, 7, 8, 13, 23, 25, 26, 28, 30–33, 35, 38, 42, 43, 47, 52, 53, 72, 77, 85, 88, 94, 99, 100, 102–106, 114
Shrub collection, 30, 50, 51, 60, 72
South Street Gate, 16, 37, 76, 78
Valley Road, 29, 37, 74, 75
Volunteers, 41, 87, 124, 125
Wilson, Ernest, 9, 46, 53, 61, 63, 72, 73, 75, 85, 100, 101, 112, 114
Wyman, Donald, 9, 48, 53, 57, 66, 71, 81, 82, 90, 94, 107, 108, 110, 115

Discover Thousands of Local History Books
Featuring Millions of Vintage Images

Arcadia Publishing, the leading local history publisher in the United States, is committed to making history accessible and meaningful through publishing books that celebrate and preserve the heritage of America's people and places.

Find more books like this at
www.arcadiapublishing.com

Search for your hometown history, your old stomping grounds, and even your favorite sports team.

Consistent with our mission to preserve history on a local level, this book was printed in South Carolina on American-made paper and manufactured entirely in the United States. Products carrying the accredited Forest Stewardship Council (FSC) label are printed on 100 percent FSC-certified paper.